DEGAS AT HARVARD

DEGAS AT HARVARD

Marjorie Benedict Cohn and
Jean Sutherland Boggs

with a poem by Richard Wilbur

and collection checklist by
Edward Saywell and
Stephan Wolohojian

Harvard University Art Museums
Cambridge, Massachusetts

Yale University Press
New Haven and London

This catalogue is published in conjunction with the exhibition *Degas at Harvard*, organized by the Harvard University Art Museums (HUAM), Cambridge, Massachusetts, on view at the Fogg Art Museum, HUAM, August 1–November 27, 2005.

Funding for the exhibition and catalogue has been generously provided by Mrs. Arthur K. Solomon, Manson Benedict, and the Edward A. Waters Publication Fund in the Andrew W. Mellon Publication Funds.

Cover:
ALICE VILLETTE (detail), 1872
(fig. 18, no. 1)

Frontispiece:
UNTITLED (SELF-PORTRAIT IN LIBRARY) (detail), 1895
(fig. 88, no. 71)

Published by the Harvard University Art Museums

Evelyn Rosenthal, Head of Publications
Editing: Evelyn Rosenthal, Carolann Barrett
Cover design: Steve Hutchison
Design and production: Becky Hunt
Printing: Finlay Printing, Bloomfield, Conn.
Distributed by Yale University Press, New Haven and London

Photography: All photographs, unless otherwise credited, are by Junius Beebe III, Katya Kallsen, Allan Macintyre, and Julie Swiderski of the Digital Imaging and Visual Resources Department, Harvard University Art Museums. Figs. 1, 47: courtesy Philadelphia Museum of Art; figs. 2, 43: ©2005 Museum of Fine Arts, Boston; fig. 6: photograph © 1998 The Metropolitan Museum of Art; figs. 7, 34, 35: photograph by Robert Pettus; fig. 13: courtesy Smith College Museum of Art, Northampton, Mass.; figs. 16, 25: Erich Lessing/Art Resource, NY; figs. 29, 46: courtesy of Dumbarton Oaks Research Library and Collection, Washington, D.C.; fig. 36: courtesy Janine and J. Tomilson Hill; fig. 37: © Sterling and Francine Clark Art Institute, Williamstown, Mass.; fig. 42: courtesy Rhode Island School of Design; figs. 86, 87: Smith College Archives, Smith College.

Library of Congress Cataloging-in-Publication Data

Cohn, Marjorie B.
 Degas at Harvard / Marjorie Benedict Cohn and Jean Sutherland Boggs ; with a poem by Richard Wilbur, and collection checklist by Edward Saywell and Stephan Wolohojian.
 p. cm.
 Published in conjunction with the exhibition "Degas at Harvard", held at the Fogg Art Museum, Aug. 1–Nov. 27, 2005.
 Includes bibliographical references.
 ISBN 0-300-11144-4 (pbk. : alk. paper) — ISBN 1-891771-40-x (pbk. : alk. paper)
 1. Degas, Edgar, 1834–1917—Exhibitions. 2. Degas, Edgar, 1834–1917—Appreciation—United States—Exhibitions. 3. Art—Private collections—Massachusetts—Cambridge—Exhibitions. 4. Fogg Art Museum—Exhibitions. I. Boggs, Jean Sutherland. II. Saywell, Edward. III. Wolohojian, Stephan. IV. Degas, Edgar, 1834–1917. V. Title.
 N6853.D33A4 2005
 709'.2—dc22 2005015241

CONTENTS

M USEUM DISCOURSE TODAY, particularly in its market-driven, super-heated rhetorical guise, tends to regard the terms "university art museum" and "teaching collection" as denoting lesser entities. It is as if a teaching and research mission in a university context somehow excludes or renders tangential great works of art; or that transcendent images or objects in that environment are simply the equivalent of, as one critic recently suggested, "gym equipment for pumping up art historians."

While university art museums are purposely not structured as "masterpiece" collections— teaching and research initiatives stretch far beyond the usual collecting imperatives of aesthetic and historical distinctiveness—a very few have extraordinarily rich holdings that defy such a model. The Harvard University Art Museums and its works by Edgar Degas perfectly illustrate that exception. Rich, deep, and broad in its contents and ranging across a variety of media, *Degas at Harvard* underscores this institution's historic commitment to Degas and his role in the development of modern art. Marjorie B. Cohn and Jean Sutherland Boggs beautifully evoke the individuals and attitudes so instrumental to collecting Degas here at the Art Museums, narratives replete with elements of vision, persistence, and even doubt. Those impulses ultimately arc back to a little-known fact that forever binds together Degas and Harvard: the Fogg Art Museum's loan show of 1911 was the artist's only one-man exhibition held during his lifetime in any museum in the world.

With some seventy works by the artist, in number alone Harvard's collection is impressive. It is equally impressive to see how these holdings continue to be strengthened and enhanced. Well represented at the Harvard Art Museums are Degas's earliest works as a student, when he made insightful copies of some of the masterworks of earlier periods. Remarkable too are the important canvases painted during Degas's stay with his family in New Orleans. The collection can also claim such canonical ballet-related works as the sculpture of the *Little Dancer, Aged Fourteen* and *The Rehearsal*, a painting that was actually part of the 1911 exhibition. And then there are the bold bather drawings of the artist's later career, which were a particular passion of Paul Sachs, one of the great champions of

drawings in the twentieth century. The University's collection also invites a glimpse into Degas's private world, with intimate portrait photographs, a rare publication of some of his sonnets, printed privately and distributed only to the artist's closest circle of friends, and a letter written one August evening to the sculptor Bartholomé.

This rich body of work, like all collections at the Fogg, Busch-Reisinger, and Sackler museums, is fundamentally a "working" collection, but one of the very highest order. It is continually used in a variety of ways by students, faculty, researchers, conservators, conservation scientists, interns, fellows, and general visitors—all the constituents of a teaching museum. *Degas at Harvard* convincingly demonstrates the fundamental role works of art play in an advanced university education. The works included not only elucidate cultural, social, and creative currents in nineteenth-century France, but are also evidence of cognitive and visual processes that have no medium of communication other than a work of art. In short, these extraordinary works teach in ways that the rest of Harvard cannot. Perhaps most important, they help shape critical looking and thinking in unexpected ways, in the process transforming lives, and is that not the essence of a university education?

None of this would happen, of course, without the foresight and generosity of many individuals who helped create this great resource. As the authors make abundantly clear, the Fogg's own Paul Sachs played a pivotal role in the collecting of Degas in the United States, including generous and important gifts of his own to us. We would like to think that his spirit has infused those who followed in his footsteps with gifts to the collection, and those who continue along that path with recent or promised gifts: Marjorie B. and Martin Cohn, Janine and J. Tomilson Hill, David Leventhal, Emily Rauh Pulitzer, and Mrs. Arthur K. Solomon. Their generosity has both strengthened and broadened the capabilities of our holdings, and we are forever grateful. Edward Saywell had the initial idea for an exhibition of Harvard's Degas works, and we owe thanks to him and to Stephan Wolohojian for organizing it, as well as for researching and coordinating the checklist information. We are also deeply thankful to those who helped make this exhibition and catalogue project possible with their usual understanding and generosity—again, Mrs. Arthur K. Solomon, Manson Benedict, and the Andrew W. Mellon Foundation. Finally, I want to thank Professor Edward L. Keenan, director of Harvard's Dumbarton Oaks Research Library and Collection, for kindly agreeing to loan their two important Degas paintings, and Michael Clarke, director of the National Gallery of Scotland, where the paintings had been on loan, for making possible their further loan to us, as well as William Stoneman of Houghton Library, for the important loans from their deep holdings.

Thomas W. Lentz
Elizabeth and John Moors Cabot Director

ACKNOWLEDGMENTS

FOR THEIR ENCOURAGEMENT, Jean Sutherland Boggs thanks Gyde Shepherd and Anne d'Harnoncourt. For his initial suggestion of the project and invitation to participate, and his continuing support, Marjorie Benedict Cohn thanks Edward Saywell. She thanks Richard Wilbur for his reminiscence of Degas at Harvard in 1947 and his gracious permission to reprint his poem "L'Etoile" in this catalogue. For information and research assistance, she gratefully acknowledges the curators of the exhibition and also James Cuno, Michael T. Dumas, Richard Kendall, Eugenia Parry, Emily Rauh Pulitzer, Jean-Marie Rouart, Eunice Williams, and curators, archivists, registrars, and librarians at the Radcliffe Institute and Harvard University, the Boston Museum of Fine Arts, the Metropolitan Museum of Art, the Museum of Modern Art, and the Grolier Club in New York, the Philadelphia Museum of Art, and the Art Institute of Chicago. Above all, she extends her thanks to Abigail Smith, archivist of the Harvard University Art Museums.

The curators of the exhibition, Edward Saywell and Stephan Wolohojian, are profoundly grateful to all our curatorial colleagues for their sage advice and assistance throughout this project. Particular thanks must be given to Kerry Schauber and Michael T. Dumas for their invaluable support, as well as to Jodi Hauptman at the Museum of Modern Art. In making this exhibition and catalogue a reality, many here at the Harvard University Art Museums have assisted with great patience, kindness, and skill: in our paper lab, Craigen Bowen, who oversaw the reexamination of all of our drawings, and her colleagues in the painting and object labs who carried out with such care the conservation and preparation of many of the other works; the registrar of the exhibition, Amanda Ricker-Prugh, who meticulously administered the many loans to the exhibition; Allan Macintyre and Jay Beebe of Digital Imaging and Visual Resources, who photographed with beauty and skill so many of the works reproduced here, and Julie Swiderski, whose color proofing work and eye were invaluable; Evelyn Rosenthal and Carolann Barrett for their ever scrupulous editing; Becky Hunt and Steve Hutchison for designing a beautiful catalogue; and Danielle Hanrahan and her colleagues Peter Schilling, John Peitso, Jill Comer, and Jon Roll for their care, dedication, and expertise with the installation, and Steve Hutchison for its outstanding graphic design.

Left:
DANCERS, NUDE STUDY (detail), 1899
(fig. 35, no. 52)

Overleaf:
TWO DANCERS ENTERING THE STAGE (detail),
c. 1877–78
(fig. 20, no. 29)

L'ETOILE
(DEGAS, 1876)

RICHARD WILBUR

A rushing music, seizing on her dance,

Now lifts it from her, blind into the light;

And blind the dancer, tiptoe on the boards

Reaches a moment toward her dance's flight.

Even as she aspires in loudening shine

The music pales and sweetens, sinks away;

And past her arabesque in shadow show

The fixt feet of the maître de ballet.

So she will turn and walk through metal halls

To where some ancient woman will unmesh

Her small strict shape, and yawns will turn her face

Into a little wilderness of flesh.

(Collected in *The Beautiful Changes and Other Poems*, 1947)

DEGAS AT HARVARD

MARJORIE BENEDICT COHN

I N HIS MEMOIRS, PAUL JOSEPH SACHS, Harvard Class of 1900, professor of fine arts, and associate director of the Fogg Art Museum, wrote: "Indeed, I have given proof of my faith by collecting twenty-nine works by Degas, for I am convinced that he was one of the greatest nineteenth-century French artists."[1] Earlier, Sachs had cheered on a former student, Henry McIlhenny, who in 1933, the year of his graduation from Harvard College, bought a Degas drawing, one that, in Sachs's congratulatory words, "I stupidly missed years ago because I thought the price of $4,000 was too high. . . . Whatever the price, you have one of the greatest drawings of the 19th century."[2] Three years later McIlhenny bought a Degas painting only four days after Sachs, who had taken it "on approval" for the Fogg and could not raise the purchase price, had returned it to the dealer. Sachs wrote to McIlhenny, "Three cheers and congratulations that you have acquired one of the greatest pictures of the 19th century."[3]

That great painting, *Interior* (fig. 1), had been on view in the Fogg Art Museum twenty-five years earlier, before Paul Sachs became the principal player in the drama of Degas at Harvard. By today's "blockbuster" standards, the Fogg's loan show in 1911 of just twelve works by Degas that were installed for only nine and a half days would barely rate a mention in a museum calendar. Yet, small and brief as it was, this was the artist's only one-man exhibition held during his lifetime in any museum in the world.[4] My account of Edgar Degas (1834–1917) at Harvard will concern itself principally with Paul Sachs, his acolyte Agnes Mongan, and their students, but it begins with the exhibition of 1911.

In 1909 Edward Waldo Forbes, Class of 1895, had become director of the Fogg Art Museum. With Forbes's arrival, Denman Waldo Ross, who had been teaching at Harvard's architecture school, transferred his allegiance to the Fine Arts Department, where he taught drawing and design theory, and to the Fogg Museum, then in its first building and location in Harvard Yard.[5] Ross was also a trustee of the Museum of Fine Arts, and in 1909 he gave to the Boston museum two pastel landscapes by Degas that he had bought fifteen years earlier (fig. 2). Doubtless he had also advocated that museum's purchase of Degas's oil painting *Race Horses at Longchamps* (L. 344) in 1903. Ross based his theories on

a thorough-going study of Asian art, and the conclusion of the description of Boston's Degas painting, the only work by a living artist listed in the "modern rooms" section of the museum handbook, likely represents his interpretation: "Many influences helped to mould the art of Degas, among them the example of Manet and the principles of Japanese decorative painting."[6]

Ross, who had little patience for academic routine and frequently traveled to Asia, always required at least one teaching assistant. In 1909 Arthur Pope was hired jointly by the Fine Arts Department as a drawing instructor and by the Fogg as the director's assistant, and it was he who organized the 1911 Degas exhibition. Beyond his dedication to Ross's theories of design, Pope had the qualification of his family: his uncle, Alfred Atmore Pope, owned three works by Degas, which he lent to the exhibition. One of these, *Interior*, had been given to him by his friend Harris Whittemore. Whittemore lent to the show another Degas painting, none other than *The Rehearsal*, which would be acquired by the Fogg forty years later (fig. 3).[7]

En route to the exhibition *The Rehearsal* met with a misadventure, as reported in Forbes's letter to the shipping company: "The painting was duly marked 'Handle with Care', and yet it evidently received such a jounce while in your hands that the frame was broken."

It seems the picture was not even wrapped: Forbes reported that its label "was shaken off and apparently fell out of the box on to the sidewalk as the box was being taken out of your carriage, for some one found it later and brought it in to us."[8]

Of course the Boston museum lent its three Degas works, and it also sent across the Charles River, as appropriate for an exhibition in an academic setting, "reproductions of drawings and photographs of paintings and pastels which show a greater range of work and also indicate the place occupied by the originals in the main gallery in relation to his work as a whole."[9] Another three originals were lent from the New York branch of Degas's dealer, Durand-Ruel, and two from a Boston collector, Frank Macomber, who was also the Fogg's insurance agent.

Although Pope wrote the preface to the gallery brochure, Forbes solicited the loans and financial support. Expenses totaled $170.70, plus $8 that Pope laid out for "electric and portable watchman's clocks," equipment ordinarily not needed to protect the Museum's minimal collection. Two dollars and twenty cents was spent for cheesecloth; its purpose is revealed by one of the favorable exhibition reviews in the local papers: "For this occasion Mr. Forbes has arranged, in the middle of the picture gallery, directly under the skylights, three screens, upon which he has draped a white wall-hanging, which forms a good ground on which to place the pictures."[10] The skylight of the "old" Fogg notoriously cast light only onto the center of the gallery floor, leaving in darkness the walls on which the paintings were ordinarily hung. By his redesign of the exhibition space, Forbes, perhaps with the prompting of Ross, approached the aesthetic of the artist, who insisted on pale walls, expansive spacing, and white or pale frames for his paintings and drawings.[11]

Fig. 2
LANDSCAPE, 1892. Pastel over monotype on paper, 26.7 x 35.6 cm. Museum of Fine Arts, Boston, Denman Waldo Ross Collection. (L. 1044)

According to his scribbled columns of figures, Forbes managed to raise only $158.98 for the exhibition, including a $40 subvention from the Fine Arts Department and $23.98 from his own pocket. Ten dollars came from Horatio G. Curtis, in response to a solicitation that Forbes sent out to several friends of the Fogg; a few years earlier, Curtis had donated a large collection of reproductions of Renaissance medals. Then Curtis saw the exhibition. As he wrote to Forbes,

> I left $10 in response to your request, but I did it before seeing the masterpieces including several of the greatest works of the greatest painter of the last fifty years, who analyses the character of ballet girls and laundresses. After reading A. P.'s foreword [which begins: "Although Degas is becoming recognized more and more widely as the greatest painter of the last fifty years"], when I saw the works, I was reminded of an incident of many years ago at the Foire de Neuilly. Outside of the tent there was a picture of a human monster of ferocity; a cannibal gobbling pieces of his victim; fangs, claws, fire running from nose, all left nothing to be hoped for. (rien à désirer). Within we found an American negro who danced and sang "Marching through Georgia."[12]

Forbes, who had learned of Curtis's reaction even before reading his letter, added a handwritten postscript to his typed response to Curtis's disdain: "Your note has just arrived. I found it very good reading. Perhaps you got ten dollars worth of amusement out of our show!"

The body of the letter reveals the Fogg director's own taste in paintings: "It seems to me that, as painting goes now-a-days, Degas ranks very high from many points of view. But I quite agree with you in finding it a very agreeable change to turn from his pictures to the early Italian pictures which are now in the background." Those early Italian pictures were largely gifts and loans to the Fogg from Edward Forbes and his family.

Then Forbes continued, asserting his intentions for the exhibition, which had been realized: "However, I think this show is an excellent thing for the Fogg Museum. It is bringing hundreds of people into the building who would never come before"— attendance over the nine and a half days totaled 550—"and who, perhaps, could have been reached in no other way except by a modern show."[13] There was the rub for men like Curtis and even Forbes, who the same year would puzzle over the difficult equation of modern art with popularity in a paper delivered to the American Association of Museums:

> In the past the policy of the Fogg Museum has been to exhibit the work of men who are dead. . . . This year we have made an innovation and have recently held an exhibition of works by Degas. . . . The advantages of exhibiting modern works of art are various. The students like it. The artists of today speak in a language the students readily understand. Art is not dead. . . . We should be alive to the tendencies of our day. The difficulty is, first, that all modern art is not good, and we wish to maintain a high standard. In having exhibitions of the work of living men we may subject ourselves to various embarrassments. . . . Broadly speaking, we had better keep to our specialty of Italian primitives, except insofar as we receive gifts and loans of other objects. And as a rule we had better let modern art find its home in the Boston Museum.[14]

Fig. 3
THE REHEARSAL, C. 1873–78
(no. 6)

Forbes's ambivalence about showing the work of living artists is evident even in the exhibition brochure. Under the title "A Loan Exhibition of Paintings and Pastels by H. G. E. Degas," in tiny, barely legible type is the briefest biographical datum: "Born July 19, 1834." Denman Ross had no such compunctions. On the day of the exhibition's opening, the Harvard student newspaper, the *Crimson,* published his letter to the Harvard community that began: "I desire to call the attention of students and other members of the University to an exhibition at the Fogg Museum of paintings by H. G. E. Degas. The painter was born in 1834, and is still living." His conclusion was even more defiant in the cause of modernity: "It is interesting to note that Harvard is for the first time giving an exhibition of modern painting. This is certainly a step in the right direction if the standard of the present exhibition can be maintained."[15]

The standard of Denman Ross was an aesthetic one, but what worried many Bostonians were the apparent moral standards of Edgar Degas, obvious to them by his choice of subjects—ballet dancers, jockeys, laundresses—and his realistic representation of them. Newspaper reviews attempted to persuade the public of the ameliorating power of art. The Boston *Globe* made an analogy to the abstractions of music: "It might be well to say that Degas is one of the very few men who could paint a ballet picture that looked decent, because as a rule such pictures are apt to be either vulgarly picturesque or picturesquely vulgar. In the ballet pictures by Degas you feel the harmonies of light, color and movement—they are almost musical."[16]

The review also offered a positive aesthetic appreciation of *Interior,* only hinting at its subject, a man and woman in a claustrophobic bedroom, whose dress and pose are suggestive of the title that the painting would receive the next year, *The Rape.* "There is one 'interior' here in which not only is a story told—and told well—but which as a composition, as an arrangement of light and shade, and lines, is really marvelous." The reviewer in the Boston *Transcript* was only a little more explicit in his description before praising the painting for its artistic qualities. "The 'Interior' . . . appears to be a story-telling picture, and the two figures in it . . . convey the impression that there has been a serious quarrel. The interior itself is delightfully painted, that goes without saying."[17] But Bostonians were not reassured, not then and not later when "the picture was shown to the purchase committee of the Boston Museum, which was going to buy it, but some women were against it, saying the picture was immoral: this couple weren't married, as the bed was a single bed."[18]

Over and over again, the proponents of Degas's modernism had to contend with his shocking subjects. In a major early treatise on modernism published in English in 1908,

Julius Meier-Graefe allowed that "Degas, when he paints his shop-girls, always means more than hats, dresses and faces, and this significance for which the poor shop-girl and the well-known dancer are in themselves insufficient, offends our less aspiring minds. [C]reatures whose chief pre-occupation seems to be the carrying of band-boxes or the taking of baths, receive a certain hieratic impress which seems incompatible with the mental attitude of those small fry, and with what they call forth in ourselves."[19]

Ten years after the Fogg's Degas exhibition, the Metropolitan Museum of Art in New York succumbed to pressure "from a group of art lovers who felt that the educational value of [a loan show of French painting that included works by living artists] would be greater if held in our Museum, where the modern works could be easily compared with examples of art of long-recognized excellence, shown in near-by galleries." Among the works by Degas, which included dancers, shop-girls, and bathers, the museum exhibited *Interior*. The catalogue preface aligned the artist with the realist movement, from Ingres through Corot and Manet, and then confessed to his untoward choice of subjects: "Degas was a subtle and fastidious realist with strange psychological interests which he applied to types strictly of his own day, the like of which had never been utilized before."[20]

In 1911 Denman Ross had suggested to Forbes that the Boston collector and artist Sarah Choate Sears might lend two Degas works that she owned, including a superb pastel of a bather (fig. 4).[21] Forbes reassured Sears that "We are to have an extra watchman by day, and a night watchman during the exhibition," but she responded to Forbes's request only after the exhibition opened without her works, pleading the fragility of the pastels and their "old frames." Did she know what had happened to Whittemore's *Rehearsal*? But she also wrote that she had heard that the exhibition was "so interesting," and she "should already have been out, had not my motor had an accident the last two days."[22]

Sarah Choate Sears must have appreciated the Fogg's ever-growing interest in Degas over the next fifteen years, for in 1927 she donated her bather to the Museum, perhaps to honor the opening of the "new" Fogg, with its well-lit galleries. In 1908 her *After the Bath, Woman with a Towel* had been singled out by Meier-Graefe as his chosen example of a creature whose chief preoccupation was the taking of baths. He described it as "a voluptuous arabesque, that yet remains human and intimate."[23] To this day the late pastel, in which the reticent nude is formed and framed by gridded strokes of incandescent color, stands apart from every other Degas in the Fogg's collection. In its reliance on shape and not line, hue and not tone, it alone represents the Degas of Denman Ross and Arthur Pope, and not the Degas of Paul Sachs and Agnes Mongan.

W HEN IN 1911 PAUL SACHS WAS ASKED to join the Committee to Visit the Fogg Art Museum—the equivalent in prestige if not power of a board of trustees—he was known only as a distinguished print collector. One month prior to the Degas exhibition, he had donated to the Fogg an impression of Rembrandt's *Great Jewish Bride* and also a work of modern art, an etching by Jean François Millet, the artist of the heroic rural poor. Millet's works were immensely popular in proper Boston, as contrasted to depictions of the squalid urban poor, which were appreciated only by a few.[24] Not incidentally, Sachs was also the eldest son of Samuel and Louisa Goldman Sachs. He worked at the family investment bank and could be expected to become very rich and, perhaps, generous to Harvard at a much higher level.

The more Edward Forbes became acquainted with Sachs, the greater his appreciation grew for the younger man's capacity both as a subtle connoisseur and as an energetic administrator, and so in 1914 he asked him to leave banking for museum work. The most important original art at the Fogg, the aggregate of the Gray and Randall print collections, was without a specialist curator, and Forbes also must have felt he needed a more worldly assistant than Arthur Pope, who was described by a former student as "a marvelous kind of poetic, vague individual."[25] Sachs was thrilled by Forbes's offer of a job at the Museum, and, although married and the father of three little girls, he gave up his "prospects" on Wall Street and moved to Cambridge.

That Forbes originally supposed that Sachs would focus on prints is suggested by his instructions to Pope, now reduced to third in line, when the director was setting off to join his assistant abroad in 1917: "[T]here is in the Gray Fund $389.00 available for the purchase of prints. I think the chances are that Paul will find opportunities in Europe to spend that money wisely, and so I advise you not to spend it unless you see something overwhelming. . . . There will apparently be somewhere between $5000.00 and $6000.00 available for the purchase of works of art in general. I think probably Paul and I will find chances and will decide over there what to purchase with that money."[26] Forbes made no specific mention of drawing purchases and certainly did not yet think of Sachs in that connection. Although as early as 1912 Sachs had acquired a few seventeenth-century Dutch drawings, parallel to his interest in Rembrandt prints, he would not buy major sheets until 1918, and the most important of those, purchased the next year, was by Antonio Pollaiuolo, a study for his engraving *Battle of Naked Men*. Sachs owned what was conventionally believed to be the finest impression in the world of that print.[27]

Fig. 4
**AFTER THE BATH, WOMAN
WITH A TOWEL**, c. 1893–97
(no. 18)

In Paris in 1918, with German artillery still close enough to lob shells into the city, Sachs had two profoundly instructive experiences. He visited the society portraitist Léon Bonnat,

whom he had met on an earlier trip. In Sachs's words, "Of all the interesting people I met through Carle Dreyfus in 1909, no one fascinated or influenced me more in the next thirteen years than the painter, Léon Bonnat. . . . He influenced me by his example to move from Prints into the more hazardous and exciting field of Master Drawings. . . . It was the delight that we shared in the work of Degas that made things click."[28] Bonnat had been a friend of the young Degas in Rome more than a half-century earlier, and he still retained the oil portrait that Degas had painted of him (L. 111).

More influential, however, may have been what Sachs learned not of the experiences of Bonnat's student years but of the means that had made them possible, and of the artist's intention to repay his moral debt. Bonnat was a native of Bayonne, and "at the provincial level, there was an established tradition of French collectors forming collections with the intention of bequeathing them to their native towns. [T]he most striking practitioner of this civic generosity was [Léon Bonnat], who amassed his remarkable collection expressly intending to endow his native town . . . in gratitude for a scholarship that had enabled him to study in Paris and Rome in his youth."[29] Surely, it was no coincidence that just about thirteen years later—the span specified by Sachs as the time it took for Bonnat's example to ripen within him—the Harvard graduate would write to Denman Ross, "[Y]ou know how much I have at heart the development of a really significant collection of drawings—that is, undoubted and authentic works by the great masters—a type of art that seems to me to be peculiarly appropriate to a University Museum like this."[30]

The second seminal experience for Sachs in Paris in 1918 was his attendance at some of the sales of the contents of Degas's studio, held over two years following the artist's death in 1917. "[T]he French officers in their light blue uniforms, briefly away from the front, bidding enthusiastically for the drawings as they came up, made deep impressions on him."[31] The sales were immensely popular; it was reported that six thousand people attended one of the viewings, but because the catalogues had not been ready in time for transatlantic shipment, few Americans were in a position to buy directly.[32] Sterling Clark was there and bidding; Sachs was there but, as far as we know, he would buy his first Degas drawing only after his return. On January 10, 1920, he purchased a portrait of Édouard Manet in New York for $350 (fig. 66).

Fig. 5
STUDY FOR "WOMAN SEATED BESIDE A VASE OF FLOWERS (MADAME PAUL VALPINÇON?)," 1865
(no. 38)

Fig. 6
A WOMAN SEATED BESIDE A VASE OF FLOWERS (MADAME PAUL VALPINÇON?), 1865.
Oil on canvas, 73.7 x 92.7 cm. Metropolitan Museum of Art, H. O. Havemeyer Collection, Bequest of Mrs. H. O. Havemeyer, 1929, 29.100.128.
(L. 125)

A more important Degas acquisition came four months later. On May 20, Sachs bought *Study for the "Portrait of Mme Hertel" (Woman with a Bouquet of Chrysanthemums)*, as it was then known (fig. 5). The drawing is now called *Study for "Woman Seated beside a Vase of Flowers (Madame Paul Valpinçon?)*," as both the woman and the flowers have since been reidentified. The painting for which the drawing is a study (fig. 6) would be deposited with Degas's dealer, Durand-Ruel, only in June of that year, but it had already been reproduced in the first monographs on the artist, and so Sachs must have known of the significance of his new acquisition.

Although Louisine Havemeyer, a friend of Mary Cassatt and a precocious Degas collector in New York, bought the painting in November 1920, she did not lend it to the Metropolitan's precedent-setting modern art exhibition the next year. William M. Ivins, the museum's print curator and Sachs's lunch-hour collecting compadre of a decade earlier, did, however, organize an associated exhibition of drawings and borrowed no less than fourteen sheets from Sachs. Three Degas works traveled from Cambridge to New York, but *"Mme Hertel"* was the only drawing among all fourteen that Ivins complimented in his report back to Sachs: "Your Degas head has the place of honor in the center of the center gallery—so very fine!"[33]

Even after Sachs had accumulated many more drawings by Degas, *"Mme Hertel"* held its place at center stage. The moment when Sachs himself understood the portrait's paramount importance occurred in April 1934, when it sealed the spiritual bond between him and Henri Focillon. Although Focillon was a historian of medieval art, Sachs acknowledged that "our topic of conversation whenever we met was very likely to be Degas." Naturally enough, when Sachs invited Focillon to lecture at Harvard, the French scholar inquired whether his talk should be on his professional specialty or Degas. In his response, after a perfunctory nod toward Harvard's most eminent art historian, the medievalist Arthur Kingsley Porter, Sachs admitted that he could not "resist the opportunity of having you speak to my students and the others about the drawings of Degas, since that is a field of interest of my own."[34]

Sachs wrote Focillon after his visit, "There are times in life when it is not necessary for one friend to say much to the other because there are certain profound impressions and emotions that transcend mere words. I think that you and I have lived through such an experience over this week-end because in all the twenty years that I have been here, no scholar on our lecture program has so deeply stirred my mind and heart. Your discussion of the drawings of Degas was a masterpiece of the highest order and a demonstration of what the word 'teaching' really means."[35]

Focillon replied, "Sometimes we encounter in life persons who love the same things that we do, but it is extremely rare that they love them in the same way that we do, with the same deep passion, and that they meld them equally into the poetry of their lives. I remember your words, their tone, their movement 'from within,' and I remember too your silences, our complicit manner, in sum, if I may say so, our fraternal delectation before the same masterworks."[36]

After Focillon's death, in the issue of the *Gazette des Beaux-Arts* dedicated to his memory, Sachs published extracts from their correspondence and added his own gloss. This is the single extended surviving account by Paul Sachs of his own sensibility as a connoisseur and collector of the work of Edgar Degas:

Fig. 7
LANDSCAPE, 1890–92
(no. 65)

One evening in the winter of 1934 at Shady Hill [Sachs's home], we were looking at the twenty-one drawings by Edgar Degas now in the Fogg collection. We were in agreement that if we could choose but one example, it would have to be . . . the sketch for the portrait of Mme. Hertel. . . . We tried to analyze this preference and found that it was due to the fact that this wistful drawing, more than any in the lot, seemed to us to illustrate perfectly the superb capacity of Degas as a draftsman; the artist's vital imagination and visualization of actuality; what Focillon delighted in calling a "sensibilité" quite absent in even the finest of Ingres' drawings and also, he added, "la plus spirituelle finesse"—a triumph of French taste. We also agreed that in this particular work Degas depicted gestures with keen observation. In delighted unison we agreed that Degas always recorded gestures and movements which were the result of and reflected fixed habits, associated with particular professions and the exertions characteristic of his varied models. We were, however, baffled by the ingenuity of the artist who, with such economy of means, could render those qualities of French charm and repose which set their stamp of time, place, station and nationality upon the sitter.[37]

Sachs also included in his memorial a letter that Focillon had sent to him in 1939, after meeting the artist Carl Pickhardt, who was engaged to marry Sachs's daughter: "He is of the legacy of Saint Edgar Degas. We can inscribe him among the members of the S.S.B (Seraphic Sensuality Brotherhood), of which you are the Grand Master." On the letter, Sachs underlined two words that Focillon had written in English: "Seraphic Sensuality."[38]

STUDY FOR "WOMAN SEATED BESIDE A VASE OF FLOWERS" (the former *"Mme Hertel"*) epitomizes the particulars of Paul Sachs's taste in Degas. First and foremost, it is a portrait. His preference for portraits was marked, and among his works by Degas, he ultimately acquired a total of ten. Degas was known as a portrait artist, and so this density of the genre is not in itself exceptional, yet among Sachs's drawings by other nineteenth-century French artists such as Delacroix, Corot, and Millet, who are not so renowned as portrait artists, likewise, the best are portraits. The human basis of the collector's focus on the portrait was implied by Agnes Mongan when she remarked on his "tremendous" interest in private collections. Such an interest could always be antici-pated in a man who was building a museum's collection, yet Mongan suggested a deeper projection: "Because every collection displayed, inevitably, something of the character of the person who had put it together."[39]

It is not incidental that so few Degas landscape drawings or prints were acquired during the years that Sachs and then Mongan were collecting for the Fogg. Two have come later: an early drawn view of the environs of Naples that was purchased in honor of James Cuno, a recent Fogg director who is equally mad for Degas, and an abstract landscape monotype,

Fig. 8
A BALLET DANCER IN
POSITION FACING THREE-
QUARTERS FRONT,
c. 1872–73
(no. 48)

the gift of Emily Rauh Pulitzer (figs. 53, 7). As a collector and scholar, Pulitzer has focused on contemporary art, and this work by Degas, far more radically modern than the landscapes acquired by Denman Ross, could not be further from the portraits favored by Paul Sachs.

Looking beyond its subject, *Study for "Woman Seated beside a Vase of Flowers"* is a drawing in fine black lines on white paper. Sachs's taste had been formed by fifteen years of print collecting before he discovered drawings, and once converted, his parameters of choice usually remained within the monochromatic conventions of old master drawings. Thus his first and arguably his greatest Picasso drawing, *The Bathers*, which he bought from the same Parisian dealer as the Degas in the same year—perhaps even on the same day—is also drawn in black line on white paper, a line as pure as Picasso's etched line; among the few prints that Sachs would continue to pursue after 1920 were Picasso etchings. Very few of his Degas drawings have any color, and among those that do, almost all provide it through their support: colored paper, on which the drawing is laid in shades of black, white, and gray. *A Ballet Dancer in Position Facing Three-Quarters Front* on pink (fig. 8) and *Young Woman in Street Costume* on tan (fig. 39) are easily related to Albrecht Dürer's *Susannah of Bavaria* on green, which Sachs also purchased in 1920. Even when by the 1930s his acquisitions showed an appreciation of the artist's late style, he did not collect any work with the vibrant color that so marks Sarah Choate Sears's pastel bather (although cost must also have played a role in his more restricted selection). In 1932 he acquired three late bathers; these were drawn entirely in black charcoal, one on white, one on yellowish, and one on a subtly pink paper (figs. 74, 9, 33).[40]

That he purchased the late bathers and, three years earlier, another one that was lightly colored with touches of muted pastel (fig. 10) indicates that Sachs had no concern about the impropriety of their subject or about the artist's realist style in rendering them, unlike his colleagues at the Fogg. Sachs was, after all, the ardent admirer of *Interior*, which he would never succeed in acquiring for the Museum, and a few years earlier he had lost a tussle about a nude with Edward Forbes. Sachs wanted to install a life-size sculptured female nude in the courtyard of the "new" Fogg, but Forbes found it unacceptable as the centerpiece of a college museum.[41]

Fig. 9
AFTER THE BATH, WOMAN
DRYING HERSELF,
c. 1893–98
(no. 43)

Fig. 10
AFTER THE BATH,
c. 1892–94
(no. 44)

Fig. 11
**STUDY OF A HORSE FROM
THE PARTHENON FRIEZE,**
c. 1854
(no. 35 recto)

Fig. 12
**STUDIES FOR "THE
DAUGHTER OF JEPHTHAH,"**
c. 1859–61
(no. 34 recto)

Fig. 13
**THE DAUGHTER OF
JEPHTHAH,** 1859–60. Oil
on canvas, 195.6 x 298.5 cm.
Smith College Museum of
Art, Northampton, Mass.,
Purchased with the Drayton
Hillyer Fund.
(L. 94)

Times would change. At Harvard on the G.I. Bill in 1947, the poet Richard Wilbur attended a seminar taught by Sachs's successor in the Fine Arts Department, Frederick Deknatel. His most vivid recollection is of Deknatel and Agnes Mongan, who had just become the full-fledged curator of drawings, showing him "a number of Degas drawings in the Fogg collection, and we discussed whether or not—in a female nude awkwardly toweling herself after a bath—there was an element of sadism."[42] This was an old theme in Degas discourse: Joris-Karl Huysmans, who admired Degas bathers on exhibition in 1886, wrote: "It seems as though, exasperated by the sordidness of his surroundings, he must have wished to make reprisals, to hurl the most flagrant insults at his century by demolishing its most constantly enshrined idol, woman, whom he debases by showing her in her tub, in the humiliating positions of her ablutions."[43] But it is amazing to imagine Agnes Mongan participating in the continuing critical discussion of Degas the misogynist. She was a fearsome defender of proprieties, wearing gloves and a hat with a veil to her classes even in the 1960s.[44]

Both Mongan and Sachs greatly appreciated another aspect of the artist's practice that was always brought forward by his conservative defenders: his lifelong activity as a copyist of historical art, as training and stimulus for his own artistic practice. A double-sided sheet of studies after the sculpture of the Parthenon was given to the Fogg by Edith Helman in honor of Agnes Mongan in 1964, when the curator was nurturing her own cadre of collectors (fig. 11). It came from the same dealer who provided Marian Phinney, another of Mongan's female admirers, with another double-sided sheet of studies, which Phinney bequeathed to the Fogg in 1962 (fig. 12). That drawing was for Degas's own history painting *The Daughter of Jephthah*, which showed him to be of the lineage of Ingres (fig. 13). One suspects that Mongan had guided both women toward their purchases.

Sachs acquired Degas's *Portrait of a Woman, after Anthony Van Dyck* and *Virgin and Child, after a Painting in the Collection of Edmond Beaucousin, Paris, by a Follower of Leonardo da Vinci* (figs. 62, 56). In his collection they accompanied Ingres's *Four Figure Studies after*

Andrea del Sarto and Delacroix's *Anne of Cleves (after Holbein)*. For the Fogg, Sachs bought two Degas studies after Benozzo Gozzoli (figs. 55, 57). Although the drawings are recorded as the gift of his best friend from undergraduate days, Henry S. Bowers, who later worked for Goldman Sachs and managed his college chum's money, in the same year Bowers "gave" an Italian quattrocento painting (Forbes's pet period) and a large group of twentieth-century English wood engravings. The print register specifies individual prices and the dealers from whom they were obtained, which allows the deduction that, as was his custom, Bowers gave Sachs cash, and Sachs and Forbes allocated its expenditure.[45]

Years later, the trustees of the Museum of Modern Art voted to deaccession several Degas studies after old masters that had come to the New York museum in the bequest of one of its founders, Lillie P. Bliss, and to give one to the Fogg (fig. 63). Sachs had been a founding trustee of MoMA, and the museum's first director, Alfred Barr, who had been handpicked for the post by Sachs, wrote to his mentor, "Knowing your interest both in Clouet and Degas we believe that this drawing would appropriately take its place in the Fogg collection, particularly as it offers interesting evidence of the continuity of the great tradition of French draftsmanship."[46] The drawing after Clouet was not the most impressive of the Bliss drawings, and others among them went on the market. One, after a portrait sometimes attributed to Pontormo, da Vinci, and others, has just come to the Fogg from David M. Leventhal, Class of 1971, who worked in the Fogg drawing department as an undergraduate and fell in love then with the irresistible Degas (fig. 14).

Study for "Woman Seated beside a Vase of Flowers," Picasso's *Bathers*, and Dürer's *Susannah of Bavaria* were only three of the drawings that Paul Sachs purchased in 1920. They were joined by a Clouet (hence the aptness of Barr's choice twenty-three years later), a Van Dyck, an Ingres, and two Tiepolos, to touch only on the high points. No wonder that the next year, back in Cambridge, he wrote to Arthur Pope, who was having his turn in Europe: "I notice that some of the fine things [in the Alphonse Kann Collection] went at reasonable prices, but alas, I am out of the running just now (and expect to be all through this year), since I must still pay for a number of the things that I bought during my stay abroad." And financial times were bad, as Forbes wrote to Pope, who was scouting out the fabled Demotte Collection for the Fogg: "[B]oth the Sachs family and my family feel, at present at any rate, that they cannot give anything substantial, and Paul and I feel that unless our two families can lead off with fairly large subscriptions it will be almost impossible to do anything." All along, Sachses and Forbeses had provided subventions for every aspect of the Museum's operations, including acquisitions.[47]

Family finances would recover in the 1920s, and Sachs continued to acquire Degas drawings. Determined not to miss a chance, he would overleap his immediate resources

Fig. 14
PORTRAIT OF A WOMAN,
AFTER A DRAWING IN THE
UFFIZI THEN ATTRIBUTED
TO LEONARDO DA VINCI,
c. 1858–59
(no. 54)

and pay for some, such as his bather in colored chalks and *Young Woman in Street Costume*, over a period of years; but perhaps this was because at the same time and also on the installment plan he was purchasing his superb Watteau *trois crayons* drawing *Six Studies of Heads*, for which the last payment alone was almost $10,000.[48] The year that he completed these purchases, 1929, he also bought his two Degas studies for the portrait of Diego Martelli (figs. 15, 40).

Financial resources for the Fogg and the Sachs family became far more straitened in the Great Depression. In 1933 Sachs was invited to lecture in France, and his correspondence on administrative matters is filled with discussion of dwindling donations and pay freezes. Yet in his first letter back to Forbes, Sachs wailed, "It is hell to be in Paris—a museum man and collector of French drawing and no money!!!!" His exclamation points were doubtless sparked by an exhibition he had just seen: "Rosenberg also has a *great* Degas show of *Drawings*." Five days later, he wrote resignedly that he had spotted "musthave Delacroixs—splendid sketches for St. Sulpice and a whole group of Degas. However my interest must be purely academic."[49]

Degas bulletins continued to arrive from Paris: "There are some truly splendid drawings in the market—just a few—but what is the use in talking about them—unless Fogg; M.F.A.; Paine; Winthrop; Hofer; etc etc are interested to have me report. I am ready to get to work on that . . . for one or two by Degas. . . . But why trouble you—when probably people at home are as blue and broke as ever." And, three days later: "I am on the track . . . of 2 superb paintings by Degas—for Paine or M.F.A; —One is at Rosenberg . . . the other the Louvre may buy in the next few days; —if not I have first chance for Boston." Ten days later it occurred to Sachs that even if acquisitions were still impossible in 1934, "if conditions warrant" the Fogg could "hold 'the Degas show' of the century—to celebrate the great man's 100th anniversary."[50]

This last letter crossed one from Forbes, alarmed by such runaway Degasmania: "I know your tremendous enthusiasm for Degas, and know that you are always finding marvelous Degas'. Much as I like him, I do not think that we want to get over-balanced and get an enormous collection of Degas at the expense of other things, which might have more value to the teaching of the fine arts courses in general. For instance, you sent a photograph of a very handsome looking landscape by Rubens [and] I raise the question of whether that might not have greater teaching value than one more Degas drawing."[51]

Fig. 15
STUDY FOR "DIEGO MARTELLI," 1879
(no. 40)

A week later Forbes, the most honorable of men and gentlest of disciplinarians, pledged to renounce $5,000 in precious Fogg acquisition funds that he might have spent on his personal collecting passion so that Sachs could buy drawings:

As regards the possible purchases with Fogg Museum money for this year there is still the same old question of whether it is better to strengthen still more our strong places or help out with our weak places. Of course, as you know, I have unabated enthusiasm for Italian primitives. . . . I feel that it ought to be the turn of the drawing department, rather than the Italian primitive department now to move ahead. However, as I said in a recent letter, we have so many good Degas' and Grenville Winthrop has so many also, that possibly strengthening some other field that is weak would really be more advantageous to the group as a whole.[52]

Fig. 16
**LORENZO PAGANS,
SPANISH TENOR, AND
AUGUSTE DE GAS, FATHER
OF THE ARTIST**, c. 1870–71.
Oil on canvas, 54 x 40 cm.
Musée d'Orsay, Paris.
(L. 256)

Sachs capitulated. "You are, <u>of course,</u> right about not getting overbalanced on my favorite 'Degas'—with Fogg funds. . . . If we never got another Degas drawing we should still have one of the best collections of that great master. So I share your view, <u>completely.</u>"[53] Note, however, that Sachs implicitly left the door open for purchases from his own funds should he recover any discretionary income.

The intensity of Sachs's hopes for the Fogg is betrayed by a slip of the pen in his next letter. He enclosed a clipping from a Paris newspaper, "in which you will find also the reproduction of the Degas which the Louvre has bought and on which, as previously stated, we had second choice. So that's that."[54] When he had first mentioned the great double portrait *Lorenzo Pagans, Spanish Tenor, and Auguste De Gas, Father of the Artist* (fig. 16), he had said there could be a chance of its purchase by the Boston Museum of Fine Arts. Now that the acquisition was impossible, in inalterable fantasy it became "we": Sachs, Forbes, and the Fogg.[55]

Y 1933 Sachs had acquired four Degas oil paintings for the Fogg. *Study for "Young Spartans Exercising"* (fig. 45) was a purchase from Museum acquisition funds, but the other three were gifts, all prompted, knowingly or not, by Sachs. *Cotton Merchants in New Orleans* (fig. 17) was purchased for the Museum by an old friend from the New York German-Jewish banking crowd, Herbert N. Straus. Sachs had borrowed the painting for exhibition from a dealer in 1929, when Straus happened to come to Boston because of the illness of his son. Sachs and his wife extended their hospitality to the concerned father, and a tour of the Fogg galleries was on the agenda. One thing led to another—in this case, as in others, to Degas.[56]

Fig. 17
COTTON MERCHANTS IN NEW ORLEANS, 1873
(no. 2)

The acquisition of another painting was a consequence of a careful campaign for Harvard causes more generally. In the flush days of 1925, C. Chauncey Stillman, Class of 1898 and already a member of the Fogg's Visiting Committee, established the Charles Eliot Norton Chair of Poetry and bought for the Museum Degas's *Alice Villette* (fig. 18). His purchase came about simply because he thought it would be a lark to go with Forbes and Sachs on one of their regular tours of New York galleries. After the painting was selected, Stillman wrote to Sachs, "Don't overlook the fun I've had in sending that Degas on to the Fogg Art. For days I've been chuckling about it. It was about[crossed out] the only thing we saw, which you wanted, and which came within my means. If I could have afforded it, I'd've sent you something greater. Nothing is too good for the Fogg Art—and I'm only following your example."[57]

The third Degas oil came as an unexpected bequest. On several visits to Chicago, Sachs called on Annie Swan Coburn, the widow of Lewis Larned Coburn, a graduate of Harvard Law School. Sachs admired Mrs. Coburn's impressionist and postimpressionist paintings, and explained to her the important work of a teaching museum; he borrowed from her a Degas for the 1929 French painting exhibition at the Fogg. Upon her death in 1932, as expected the major masterpieces of her collection were bequeathed to the Art Institute of Chicago, including Degas's great oil *The Millinery Shop* (L. 832). The painting had, however, only been purchased by Coburn the same year, from the New York branch of Durand-Ruel, where it had remained unsold for fifteen years and where Sachs had undoubtedly admired it many times.[58] One wonders whether his enthusiasm for Degas had been contagious.

In any case, to Sachs's surprise the Fogg received from Coburn ten French paintings, including one each by Manet, Monet, and Cézanne, and two by Toulouse-Lautrec. There was also a much more modest view into a millinery shop by Renoir and a small but brilliant racetrack scene by Degas (fig. 19). Forbes wrote enthusiastically to Sachs, "[T]he Coburn bequest is a great addition to our Museum. Congratulations for having pulled this off. I understand that we owe it entirely to you. . . . I agree with you that the Degas is splendid."[59]

Of the prospective private buyers for Degas drawings listed by Sachs in 1933, Robert Treat Paine was primarily a benefactor of the Museum of Fine Arts, but Forbes and Sachs had well-founded hopes that Grenville Winthrop, Class of 1885, and Philip Hofer, Class of 1921, would become major donors to the Fogg. Winthrop already owned six works by Degas, including a stunning pastel-monotype and a small oil painting, both of ballet scenes, an important drawing of a racehorse, and the incomparable bronze sculpture *Little Dancer, Aged Fourteen* (figs. 20–23). As early as 1919 he had indicated that his

Fig. 18
ALICE VILLETTE, 1872
(no. 1)

collection would come to Harvard, and he was in regular contact with Sachs, who brought his students every year to Winthrop's New York house, stuffed with art.[60] By 1933 the scale of Sachs's own collection of Degas drawings must have become apparent to Winthrop, and, sensibly, he ceased buying major works by Degas (with a single unfortunate exception, described below) and applied his funds toward nineteenth-century French, British, and American artworks that would complement the Sachs collection.

Hofer, though a graduate of the College, was a relative newcomer to the Fogg community. A bibliophile, he had worked in New York libraries and had come back to Harvard in the mid 1920s to attend Sachs's Museum Course.[61] After a trip to Europe in 1929, Sachs excitedly wrote to Arthur Pope, "I ran into considerable good luck in the matter of acquisition . . . and I may add that as I saw a good deal of Phil Hofer (who is getting to be a passionate supporter of the Fogg), between us very few first rate drawings escaped us and that we have set the necessary wheels in motion so that in future things of importance will be submitted to us even when we are not in Europe."[62] And in fact Hofer did purchase the "musthave" Delacroix drawings and donate them to the Fogg in 1934. In his warm letter of thanks Sachs wrote, perhaps not entirely truthfully, "I no longer have the slightest interest in personal possession or pride of possession, as I admit I had when I was younger, but I am more eager than ever, for such a time as remains to me here, to build not only a great collection of drawings but to attach to the Museum men of vision and generosity like yourself."[63] Yet, although one landscape monotype came to the Fogg through the bequest of Hofer's wife (fig. 24), the Degas drawings that Hofer is known to have owned at one point or other never materialized as gifts or bequests to the Fogg. Hofer was an energetic *marchand amateur*, and almost any work in his collection might be fungible if the occasion for a more important acquisition arose.[64]

Even more exciting to Sachs were two other members of the younger generation, Henry McIlhenny and John Newberry, both Class of 1933. As undergraduates they staged a joint exhibition of their art collections at Dunster House, their College residence, and Sachs made special, somewhat irregular arrangements for them to attend his course on French painting. McIlhenny had received a failing grade in another course and could only audit; Sachs welcomed Newberry but advised discretion: "I shall be glad to make an exception in your case . . . provided, of course, that neither you or [your tutor] Mr. [Benjamin] Rowland will broadcast the fact."[65]

Sachs fretted that in going to Europe during the spring semester of their senior year he would break the bond that he was carefully weaving, to connect the young men to him and to the Fogg. He gave his estimate of their capacities to Forbes and urged him to continue the social contacts that he had cultivated: "I have spoken about McIlhenny to you at various

Fig. 19
AT THE RACES: THE START,
c. 1860–62
(no. 4)

times. . . . And <u>please</u> be sure to get hold of the other 'collector youngster'—<u>Newberry</u>—who is McIlhenny's friend—and has I think even better taste and more courage intellectually."[66]

The letter that Sachs wrote to Newberry after his graduation, when the latter had expressed an interest in returning to Harvard as a graduate student, perfectly expressed the professor's not entirely disinterested hope for his two students, mediocre as they were academically: "Let me say first of all that the fact that you did not secure distinction in passing your divisional examinations will not in the least have an effect on my estimate of you. I am sure that we shall be able to work together in the <u>Museum Course</u> in such a way that beneficial results will follow, and I look forward with delight to having both you and McIlhenny in this association with me."[67]

Certainly it was Sachs and not Forbes who would be in "association" with the two. In April 1933, months after Sachs had asked him to look after his young prospects, Forbes, sounding somewhat vexed, had reported back: "I succeeded in getting McIlhenny to the house once and have asked Newberry but he could not accept, and McIlhenny never comes near me. . . . I am sorry to say that I don't even know Newberry by sight yet, I don't want to keep running after him and he never comes near me or gives me a chance to see him."[68]

That two wealthy and cosmopolitan young men avoided socializing with the middle-aged, high-Brahmin, congenitally rumpled director of the Fogg Museum is hardly surprising. Sachs should have put more faith in the sympathetic potential of his curatorial assistant, Agnes Mongan, who was stylish, lively, only a few years older, and at least as much in love with drawings as McIlhenny and Newberry. She would become their close friend when they returned as graduate students.

Mongan had arrived at the Fogg as a special student in the fall of 1928. The year before, after graduation from Bryn Mawr, she had enrolled in a Smith College postgraduate program of art history study in Europe. Her experience there was a preternaturally appropriate preparation for work under a Degas drawing collector whose principal means of acquainting his students with curatorial life was, apart from studying the works of art themselves, visiting museums, dealers, and private collectors. Mongan was guided

Fig. 20
TWO DANCERS ENTERING THE STAGE, c. 1877–78
(no. 29)

Fig. 21
BALLET DANCER,
c. 1873–1900
(no. 5)

Fig. 22
**HORSE WITH SADDLE
AND BRIDLE,** c. 1868–70
(no. 27)

Fig. 23
**LITTLE DANCER,
AGED FOURTEEN,**
modeled c. 1880
(no. 11)

through Italy and Paris by Smith professor Clarence Kennedy. He took his students to the usual sites but made their experience far more intense, taking them up ladders to study paintings at the Louvre with a binocular microscope, for instance, brushstroke by brushstroke. Carle Dreyfus, who had been so kind to Paul Sachs in 1909, was among the many private collectors and dealers in Paris that the Smith group visited.

Although the Smith students studied together, they found their lodgings individually. By happenstance, the most glamorous girl among them chose to leave her first address in Paris for a better location, or so she thought. Mongan ran to fill the vacancy: "[I]t was where Degas used to go for supper every Tuesday night . . . between Blanche and Pigalle— 22 rue de Douai." The family in residence in the spring of 1928 had succeeded the friends of Degas who had hosted the painter, but Mongan, and then Sachs when he learned of this coincidence, could have interpreted it as nothing less than Fate.[69]

Fate also intervened when Mongan arrived at the Fogg that fall and wanted to volunteer in the Museum. The same Smith student who had abandoned Degas's dinner table had just left a project under Sachs's direction that she had barely begun: cataloguing drawings. Again, Mongan stepped into her place. Sachs said to her, "All right, now start cataloguing those drawings. Here's the list, and there are the originals."[70] In her words, "[N]obody had ever put the Fogg drawings together. Or Paul Sachs's drawings together. They were in closets or dark storage. I got them together." Given his collection and her recent stay in Paris, it is no wonder that, as she said, "I began with Degas and I still think Degas is one of the greatest"—yet the continuation of her sentence implies the difference between her and her supervisor—"but I made my specialty Ingres because I wanted to get those into the catalogue correctly. There are a lot of copies and a lot of fakes. Paul Sachs had a wonderful eye and his are right."[71]

Not only did Sachs have an "eye," he also loved the apparatus of scholarship and avidly collected books and photographs. In 1919 he had tried to obtain for the Fogg a set of the photographs of all extant Degas works that Durand-Ruel had taken before the sale of the artist's studio contents. This "photographic record," Sachs wrote, "would offer us at the University an unusual opportunity to demonstrate to students how a great master works and the many phases through which he passes in the final production of a completed picture."[72]

Negotiations dragged on for months, but after "Mr. Joseph Durand-Ruel had consulted Mr. René Degas [who] saw no objection to our having this done," the firm reported that "There are it appears 2400 plates and each photograph would cost about fr.1.75, unmounted."[73] Sachs responded that "we are once more making an effort to have one of the friends of this Museum supply us with the necessary funds . . . but unfortunately . . . the cost appears to be larger than our friend for some reason had anticipated." Sachs may have been the unnamed friend, but he had begun to put all of his discretionary income into originals.[74] Sachs visited collections, he consulted art historians, and he formed generations of scholars through his teaching, but in the end he did not publish and was not himself a scholar. In 1927, the year before Agnes Mongan arrived at the Fogg, he confessed to William Ivins, "[A]s I approach fifty I realize fully if I am honest that my great and inherited capacity such as it may be is for administration and probably not at all in the field of research. I fear I love too well the world of action."[75] Sachs needed Mongan as much as she needed him.

The Fogg drawing catalogue was published in 1940, with Mongan and Sachs as joint authors. Its title is *Drawings in the Fogg Museum of Art*, and in the geographical sense that was correct, for Sachs usually kept the bulk of his collection at the Fogg. Signaling his

Fig. 25
MLLE DIHAU AT THE PIANO,
c. 1869. Oil on canvas,
39 x 32 cm. Musée d'Orsay,
Paris.
(L. 263)

commitment that all of it would belong to the Museum some day, his drawings were published along with the Fogg's. One suspects that it is the more fluent prose of Agnes Mongan that we read in the catalogue's evocation of Degas: "In his hand . . . the pencil had more freedom and moved with easier rhythms than in the hand of Ingres. Moreover, the intelligence that guided it was more subtle, more probing, and more original, so that Degas's drawings show a greater variety and suppleness of pose, a more immediate and personal interpretation of character. . . . Degas's are presented with an informality which, because of the perfect balance of his taste and judgment, in no way detracts from their distinction but reveals characters of more pulsating life."[76]

More than forty years later, in a letter to Jean Sutherland Boggs, Mongan would evoke the same qualities in far more personal terms: "In spite of the fact that my French colleagues call me 'L'Ingriste de l'Amerique,' Degas remains my greater favorite. Of all 19' c. artists, he remains to me The Top. Mind, heart, vision, talent, understanding, no one can match him."[77] A self-portrait photograph by Degas was found among Mongan's personal papers after her death (fig. 88).

Mongan was too sociable to restrict herself to cataloguing drawings in a closet, however, and Sachs's collector-protégés quickly discovered a friend and ally. Henry McIlhenny chattered on in letters, advising her whom to visit in Paris in 1935 beyond those recommended by Sachs—"the most thrilling places that I visited were not on his list. [Y]ou must not miss the Manets and Degas (and particularly the famous drawing of Manet); at Ernest Rouart's, whose studio (he paints horribly) and apartment is at 40 rue de Villejust"— asking her to purchase for him the piano belonging to the recently deceased Marie Dihau, who with her brother Désiré Dihau was a great friend and portrait subject of Degas (fig. 25)—"I am agog to hear about the Dihau piano. P. J. S. also thinks it should be preserved for posterity, and it would be an interesting thing to own, although what I'd do with it, god only knows"—and soliciting her support when, taken on as a curator by the Philadelphia Museum of Art, he received permission in 1936 to do the great Degas exhibition that

Sachs had had to forego in 1934—"I want him [Sachs] to write an introduction to the Degas catalogue, so do your best to champion my cause." Three months later McIlhenny made his pitch to Sachs: "Inasmuch as you say your middle name is 'Degas,' I don't know of anyone in the world who could do it with more authority or skill." Typically, Sachs begged off and wrote only a brief preface; Mongan wrote the introduction.[78]

Yet Sachs did help McIlhenny secure loans for the Philadelphia exhibition, because this entailed a different sort of writing that was far more congenial, a personal letter to a "passionate collector of the work of Degas."[79] Sachs wrote to Marcel Guérin, "It is not my habit to intervene on behalf of other institutions, but . . . I am taking the liberty to communicate with you about a very extraordinary exhibition of the work of Degas that is being arranged by my friend and former pupil, Henry McIlhenny. . . . You and I are such great enthusiasts for the work of Degas that I should very much like to see some of your great treasures form part of this exhibition."[80]

SEVERAL OF MARCEL GUÉRIN'S LOANS to Philadelphia in 1936 had a more extended history at the Fogg. Four photographs by Degas that were in the exhibition were eventually sent to the Museum in 1942. Sachs donated the two landscape photographs to the Museum's library (figs. 26, 44); the Fogg did not yet have a curatorial department of photography, and, indeed, the inclusion of Degas photographs in a museum exhibition or collection was unprecedented.[81] Also, after it was shown in Philadelphia Guérin's Degas painting *Self-Portrait* was sent to the Fogg, where it remained as a loan through the Second World War (fig. 37). Sachs and Guérin exchanged friendly letters about "Edgar"'s welfare but disagreed about whether "he" should be insured, with Sachs hoping to escape the expense of a premium and pleading that the picture would be as safe in Cambridge as the Fogg's own uninsured collection. Guérin insisted, and there followed a polite altercation over its value. Finally, Sachs agreed to insure it as Guérin asked, for $20,000. Then, after the war a Parisian dealer wrote to Sachs that Guérin "would like to know . . . if your Museum would like to purchase it and what your opinion is about its actual value. He told me that the picture has been insured for $20,000 but he believed that this figure was too low for a sale price."[82] As early as 1936 Sachs had tried to buy the painting, but in 1947 he responded, somewhat disingenuously, "I feel very sure that the price quoted by you (namely $20,000) is entirely too high."[83] The matter remained unresolved until after Guérin's death early in 1948, when his son Daniel informed Sachs that the firm price was $21,000. It was characteristic of Sachs that he never lost his cordial interest in finding an American home for the Degas self-portrait even though he could not afford it, and his subsequent correspondence with Daniel Guérin contained several recommendations of potential purchasers.

When war in Europe had seemed imminent, Marcel Guérin suggested to Sachs that he
might send more of his collection to the Fogg. That did not happen, but the threat of war
and then war itself did bring other Degas works to relative safety in Cambridge.

After graduating from Princeton in 1934, Arthur K. Solomon came to Harvard to study
chemistry. He was already a habitué of Alfred Stieglitz's gallery in New York and had
purchased Hopper and Burchfield watercolors, and so he asked to sit in on the Museum
Course, an exotic among the nascent curators. In his words, "As a piece of that course, at
Christmas time Sachs would take all the students to visit collections up and down the east
coast to which he had entrée. . . . We saw the Widener Collection in Philadelphia and
Widener held Sachs in such respect that he took us around his house and showed us these
pictures himself. [Stephen Clark had] really great nineteenth century pictures including
great Cezannes, [Samuel Lewissohn] the Douanier Rousseau that took up the whole of
their entrance hall. [I]t showed me that people could collect, and that you could live with
the things."[84]

Solomon went on to Cambridge, England, for a Ph.D. and began to purchase art again.
But in April 1939 he wrote to Sachs: "Recent events in Germany and elsewhere seem to
indicate that the chances of war are not remote. . . . Consequently I am sending more of
my pictures back to America. . . . There is so little time available now that I am afraid I
would defeat my purpose if I waited for a formal acceptance from the Fogg. So I shall be
presumptuous enough to send . . . two pictures . . . a charcoal drawing, heightened in
pastel, of Degas, called 'Femme nu, couchee sur un divan'. . .[and] a Picasso oil."[85]

Solomon soon followed his Degas and Picasso back to Cambridge, Massachusetts. "After
a few months, I decided I'd best go see what had happened to the pictures. I wrote . . . to
say I would like to see them. What I got was an invitation to lunch with Paul Sachs. . . .
But, the startling thing was that when I got there, my Picasso was hanging behind Paul
Sachs on the wall."[86] The Degas, although smaller and a drawing, must have been no less
attractive to Sachs (fig. 27); and Solomon, "under the sway of Paul Sachs," had the intelli-
gence later to purchase *The Masseuse* (fig. 28), Degas's unique two-figure sculpture in
which the nude reclines on the same divan as that seen in the drawing.

Another, more mysterious "Degas" sought shelter in Cambridge in 1940, perhaps as a
proposal for publication and not as protection from war. "An original, unpublished manu-
script on Degas" sent from Paris by Rose Valland was signed into the Fogg registrar's
records, "to be kept for the duration." Valland was an administrator at the Jeu de Paume,
the Parisian museum of twentieth-century art, but she was not a Degas scholar, and I have
found no clue to the author, contents, or purpose of the manuscript beyond the inscription

Fig. 26
UNTITLED (CAPE HORNU,
NEAR SAINT-VALÉRY-SUR-
SOMME), 1895
(no. 69)

Fig. 27
**YOUNG WOMAN LYING
ON A CHAISE LONGUE,**
c. 1895–1900
(no. 55)

Fig. 28
THE MASSEUSE,
modeled c. 1895–1900
(no. 16)

on its return receipt: "Received from Miss Mongan the manuscript on Degas that I had sent to her to be proposed to the Fogg Art Museum."[87] Whatever it was (and whatever the proposal was), it was exceptionally precious: on its return to France it was insured for $15,000. When Sachs's ballet dancer on pink paper, one of his most valuable Degas drawings, was sent for safe-keeping to Lessing Rosenwald's house museum in Jenkintown, Pennsylvania, in December 1941, it was valued at only $4,500.[88]

After the United States entered the war and when the major East Coast cities felt under the menace of German bombs, two Degas works, the drawing *à l'essence* of Giulia Bellelli and the oil painting *The Song Rehearsal*, arrived at the Fogg in March 1942, followed in June by a third, *Au Café de Châteaudun*.[89] These were sent up from Dumbarton Oaks, Harvard's property in the Georgetown district of Washington, D.C., the home of Mr. and Mrs. Robert Woods Bliss. As a team, Sachs and Forbes had long been the active liaison between the University and Bliss, like Sachs a member of the Class of 1900. The Blisses were generous donors to the Fogg, but their hope, ultimately realized in 1940, was that

Dumbarton Oaks would also become a Harvard museum and study center. Already collectors of pre-Columbian and Byzantine antiquities, in the late 1930s they had enlarged their art holdings with the purchase of French impressionist works, including the two major Degas works that remain at Dumbarton Oaks to this day (figs. 29, 46).

That fear of bombing made subtle geographical distinctions is indicated by the arrival at the Fogg in June 1942 of Degas's *Little Dancer, Aged Fourteen*. The sculpture was sent across the river, along with Picasso and Toulouse-Lautrec paintings that were insured for much higher valuations, by a Boston couple, Thomas and Elizabeth Metcalf. Sachs, a good friend of the Metcalfs, felt obliged to add in his cordial letter encouraging their loan that "it is understood that the Fogg Museum of Art is not to be held responsible for the destruction of the object . . . due . . . to the existence of a state of war." A year later, with the more imminent threat at the Fogg now being a lack of space, Sachs wrote again to the Metcalfs: "[I]n the Winthrop Bequest, we find that we have her 'twin sister.' So I write to ask whether you and Libby would perhaps enjoy the little lady back."[90]

Grenville Winthrop died in January 1943, and, using up all the gasoline rationing stamps the staff could obtain, by November a convoy of trucks had brought from New York to Cambridge the thousands of paintings, sculptures, drawings, jades and bronzes, clocks, furniture, rugs, and ceramics that had filled his East 81st Street home. Among them were his works by Degas, including one purchased as recently as 1939: a facsimile of *Study for the "Portrait of Duranty,"* which he had bought as an original; it had been tricked out with an "ed" monogram and touches of black and white crayon (fig. 30). But Winthrop was evidently unaware that the original *Duranty* drawing resided only a half-block from his house; the Metropolitan Museum of Art had purchased it at the Degas atelier sale in 1918.

Winthrop had correct but distant relations with the Metropolitan; Sachs had close friend-ships with many of its staff, especially with William Ivins, who was also head of the arrangements committee for the Grolier Club, a bibliophiles' library and exhibition venue in New York where Sachs had been a member since 1910. In 1922 Ivins organized the second institutional monographic Degas exhibition, for the Grolier. While this did not include loans from the Metropolitan or Sachs, it is somehow unimaginable that, given both men's interest in Degas, the original *Duranty* did not come up in conversation then or in the seventeen years prior to Winthrop's purchase. Even more astonishing was the fact that Sachs regularly used in class—and even as a memorable after-dinner entertain-ment for undergraduates—a copy of the 1923 portfolio of superb photoreproductions of one hundred Degas pastels, studies *à l'essence*, and drawings that included the facsimile of *Duranty*. The portfolio's table of contents gives the Metropolitan Museum of Art as its owner.[91] And after he bought the "drawing," Winthrop entertained Sachs at his home at

Fig. 29
GIULIA BELLELLI, STUDY
FOR "THE BELLELLI FAMILY,"
1858–59
(no. 10)

least three times that are documented in their correspondence. Knowing Sachs's passion for Degas, he must have shown off his new acquisition, yet still no alarm bells were rung.

In May 1943 the Fogg's library received a copy of *Metropolitan Museum of Art. Vol. II. Flemish, Dutch, German, Spanish, French, and British Drawings*, which reproduced the original *Duranty*. In November, after Winthrop's drawings had arrived at the Fogg, Agnes Mongan reproduced his *Duranty* in a special Winthrop issue of the Museum's *Bulletin*, as one of the highlights of his French drawing collection (in other words, among the drawings, the best of the best). In January 1944 *Duranty* appeared in special Winthrop issues of the *Harvard Alumni Bulletin* and *Art News*, where the caption reads: "Degas' 'Portrait of Duranty' in black and white chalk on blue paper breathes with life."[92] And then it dropped from public view. Sachs and Mongan must have been alerted by some reader of one of these periodicals or perhaps by Ivins himself.

Fig. 30
STUDY FOR "EDMOND DURANTY." Collotype reproduction of the drawing in the Metropolitan Museum of Art, with added touches of black and white crayon, published 1922–23.
Fogg Art Museum, Harvard University Art Museums, Bequest of Grenville L. Winthrop, 1943.808.

But then the real history of Winthrop's *Duranty* began. Jean Sutherland Boggs remembers it from 1944–45, when Sachs put the "Degas," still in the elegant decorated mat and gilded frame that Winthrop favored, before his Museum Course students, warning them against being fooled by facsimiles. After Sachs's retirement, Mongan continued the tradition in her seminars on French drawing. Eugenia Parry remembers the moment in 1961, which was for her an epiphany: "She showed us a beautifully framed facsimile reproduction of Degas's pencil portrait of Edmond Duranty at his desk. I don't know what made me dead-sure it was a repro. . . . All I know was that at the moment, standing alone, insisting that

the drawing wasn't 'right' while all my classmates confidently voted for it as an original (Agnes smiling all the while), was the threshold that brought me into the world of seeing art, as opposed to seeing other things."[93] Parry (Janis) would become the first great interpreter of those mysterious original printed drawings by Degas, his monotypes, and her catalogue of the 1968 monotype exhibition at the Fogg remains the definitive publication on the subject.[94]

AS PART OF THE COMPLEX AGREEMENT between Mr. and Mrs. Bliss and Harvard, Edward Forbes became the titular director of Dumbarton Oaks as well as the Fogg. He sent his assistant, John S. Thacher, Class of 1934, to Washington to serve as the executive director. Thacher, a Museum Course veteran, also owned Degas drawings, and his name had long since popped up in letters in which Sachs dreamed of a golden future for the Fogg. In 1933, when McIlhenny had told him that in his will he had designated for Harvard works by Chardin and Corot (a drawing Sachs had badly wanted for himself), Sachs wrote to Forbes, taking into account that Thacher and the benevolent McIlhenny were still undergraduates: "[W]e are building for a long future and some future Directors will at least get some of the things that the Thachers, Hofers, Browns, Hoyts, McIlhennys, Walkers etc etc etc are pulling in with our help. So I am quite content to 'miss' a few things now—for a future benefit."[95]

Some years later Mongan put expectations in more compulsory terms: "But Harvard men have always been generous. You can offer to keep some graduate posted if something is coming up that you know he would like, and, under these circumstances, he's got to promise to leave at least one thing to Harvard."[96] While this moral commitment might have been clear at the moment that McIlhenny, Newberry, and Thacher acquired their works by Degas, it faded as the young men became older and made their careers in other museums. McIlhenny's works by Degas, along with his Corot drawing and Chardin painting and many other masterpieces, went to Philadelphia. After Newberry's death Mongan wrote, perhaps with clenched teeth: "Newberry . . . remained loyal to the high ideals and the generosity of spirit which were so much a part of Paul Sachs's approach. . . . Newberry bequeathed his drawing collection to the Detroit Art Institute."[97] Fogg staff members remember her recounting as an example of curatorial duty the intense telephone calls that she made to a now middle-aged Newberry, to remind him that she had found for him his Watteau drawing and that, despite the riches of the Winthrop collection, the Fogg did not have an example of the excessively rare landscape drawings or early profile portraits by Ingres, which he did have. She could hardly make the plea that the Fogg lacked works by Degas, and so only the Watteau and the two Ingres drawings came to Harvard.[98]

The case of Thacher was a little different; his professional life was spent at Harvard, working for the Fogg and Dumbarton Oaks, and so he was not distracted by other institutional loyalties. A letter to him from Mongan indicates that as late as 1970 she thought that the Fogg was in line to receive his drawings.[99] But, as Mongan wrote to Jean Sutherland Boggs after Thacher's death, when the latter was trying to locate one of his Degas drawings, "You probably know that for years Jack [Thacher] had indicated that they would come to us at Harvard, but he became cross with Harvard and changed his will."[100] Forbes had a more ironic view of such situations when he wrote about "the pictures which Sachs and I toiled long and hard to get, some of which are in our gallery and most of which are not."[101]

After the war, Paul Sachs virtually ended his career as a Degas collector. Prices were too high, whether for his purse or his psyche. In 1946 McIlhenny reminded him that "during the Museum Course you once said that collectors usually are not active more than one generation because it is hard to reconcile the prices of one's youth with the prices of one's maturity. The war has telescoped a generation, and the prices in New York really shocked me."[102] When Newberry lost out in bidding for a Degas drawing in 1948, Sachs reassured him: "The 'Mary Cassatt at the Louvre' seems, to an 'old timer' like P. J. S. to have sold for far too high a price. Your bid [$3,000] was right, but $5,000. seems to me an exorbitant price." The next year the elderly Sachs, now retired, would write to Newberry, "The fact is, at my age, I am always delighted when you fellows of the younger generation make first rate acquisitions."[103]

Mongan and Sachs still held out hope for yet another active collector. In 1949 Maurice Wertheim wrote to the former associate director of the Fogg: "You have probably heard through Agnes Mongan that I had the good fortune to acquire Degas 'La Chanteuse Au Gant' [fig. 31]. It was only yesterday that I learned through John Coolidge [director of the Fogg; Forbes had also retired] that it was you that first suggested to De Hauke that he submit this picture to me. Please accept my sincere thanks for your thought of me in this matter and rest assured that I am very happy in my new possession."[104]

"De Hauke" was the dealer César de Hauke, who gave the Fogg a small Degas sketch early the same year (fig. 72). Sachs always maintained excellent relations with dealers.[105] He never hesitated to borrow from them for Fogg exhibitions, and he made sure that his students understood their importance in building a collection. As he wrote to Newberry, who in 1947 was lending his drawings to the commercial Buchholz Gallery for exhibition, "You may recall that Agnes and I, in the Catalogue, always give credit to the dealer who supplied us with the particular treasure that we are describing."[106]

Fig. 31
SINGER WITH A GLOVE,
c. 1878
(no. 7)

Maurice Wertheim, Class of 1906, had known Paul Sachs from his childhood in New York, but he was a member of the younger generation of collectors. Wertheim began acquiring modern art only in 1936 with the purchase of a Picasso blue period watercolor, followed almost immediately by a major blue period oil. He then bought Van Gogh's *Self-Portrait Dedicated to Paul Gauguin* from the Nazi auctions of "Degenerate Art," and by about 1941 he decided to bequeath his growing collection to Harvard. The next year he bought his first Degas, *The Rehearsal*, which had figured in the Fogg's pioneering exhibition thirty years earlier (fig. 3). Two Degas sculptures were added within the next few years (figs. 48, 50), and then at Sachs's instigation the great pastel of the café singer. The Fogg hastened to present the Wertheim collection in an exhibition with a full scholarly catalogue in 1946, to celebrate his acquisitions and confirm his good intentions.[107]

GIVEN THE DOUBTS EXPRESSED by Edward Forbes about collecting the work of "living men," we can assume that the 1911 Fogg Degas exhibition was not intended to promote the acquisition of any of the works it contained. And Forbes may have thought that in hiring Sachs, he had acquired a colleague who might feel the same way. In his memoirs Sachs recalled that in 1915, "I stood alone in believing that controversial modern works of art ought also to be shown, if not actually purchased."[108]

Ironically, although the first exhibition organized by Sachs that contained works by Degas was intended to cultivate a donor, their inclusion was not his first idea; old master prints were the prizes in mind. In 1921 Sachs was trying to promote an interest in the Fogg in yet another acquaintance from New York, Charles B. Eddy, a lawyer and print collector. He proposed to Eddy an exhibition that would be comprehensive, beginning with fifteenth-century German engravings. Eddy, who had substantial intellectual aspirations, thought the concept too much of a miscellany and did not even want to be known as a collector; he interpreted the descriptor in magpie terms. Sachs hastened to agree—"I also dislike the word 'collecting.' I much prefer to use the term that Dr. Ross is fond of using: 'selecting'"—and he accepted Eddy's counterproposal of a focused exhibition of prints by Degas, Pissarro, and Forain.[109]

Strangely enough, Sachs himself seemed never to have had any particular interest in Degas prints, although the artist is now recognized as one of the greatest printmakers of the nineteenth century. Only three Degas prints in the Fogg derive from Sachs: a Rembrandtesque portrait etching, a lithograph that relates to the late bather drawings, and a monotype, which to the collector was probably more essentially a drawing than a print (figs. 84, 76, 82).

Quite independent of prints, Sachs's conversion to Degas the artist was complete by 1921, when Eddy pontificated to him in a letter: "I do not regard all of the articles [that he had proposed for exhibition] of equal importance. Forain undoubtedly stands at the head, and I should place Degas below Pissarro. As regards technique . . . Degas was experimenting along lines that interested him in connection with his major work. He shows great power, but I do not believe that his prints will increase his reputation." Sachs rose to the challenge, all the while maintaining his deferential tone: "Your comments about the merits of the three men interest me very much. As artists I have always ranked them in a slightly

Fig. 32
HALF-LENGTH STUDY OF
A WOMAN, c. 1890
(no. 24)

different order than you do, namely, Degas first, Forain second, and Pissarro third, but of course, in doing this I have thought of their work as a whole and have never approached the question from the point of view of prints alone."[110]

Sachs touted the exhibition to a local newspaper critic—"So far as I know Mr. Eddy's collection is the first group of prints by these three men which has been brought together in this part of the world"—and it is hardly surprising that in the subsequent review it is the Degas portrait prints that are emphasized, and the quality of their drawing: "The etchings include three extraordinary portraits of his colleagues [Manet, Tourny, Cassatt], together with a likeness of his sister, Miss Marguerite Degas. Nothing in the way of draughtsmanship could be more masterly than the heads mentioned."[111]

One of the more curious Degas exhibitions at the Fogg—an update of the display of reproductions that accompanied the 1911 exhibition—was held, again in the print room, in 1927. To quote from a typescript by a "Mr. Newton," a text presumably destined for the Harvard *Crimson* and still preserved in the Museums' archives:

> Degas Drawings Reproduced by the Best Methods, January 22 – February 14, 1927.
> This Degas exhibition ushers in a series of Exhibitions of Reproductions of Drawings especially arranged for University students and faculty, who may buy these prints if they wish. Through the interest and cooperation of Mr. Weyhe of New York these prints have been secured at prices ranging from one dollar to fifteen dollars each, thus suited to the average student purse. . . . Now that Degas is accepted by the most conservative it is well to note his strong influence upon the work of modern painters. Considering the increasing interest in this Degas "show," opening today, those intending to purchase are urged to come early.

The next exhibition at the Fogg that contained originals by Degas was held in 1929.[112] It was a loan show, and, although its title described it as an exhibition of paintings, it contained pastels, drawings, and prints; many of the drawings were lent anonymously by Paul Sachs. Among the artists, Degas was represented by a total of twenty-eight works, and only Gauguin had a higher total, because of the many woodcuts and lithographs lent by Sachs's close friend, the Boston print collector W. G. Russell Allen. Allen would select the prints for inclusion in McIlhenny's comprehensive Degas exhibition in Philadelphia in 1936, and he lent a Degas drawing of a jockey and eight Degas prints, along with fifty other prints and three other drawings, to a Fogg exhibition, *French Paintings, Prints, and Drawings of the Nineteenth Century*, in 1942. After Allen's death in 1956 a Parisian print dealer gave to the Fogg a Degas in his honor (fig. 61). This was not, however, a print but, with an implied compliment to Sachs, a drawing—a copy after details in a sixteenth-

century Italian engraving. No gift could better embody the complex and particular associations of these men and those arts.[113]

In 1931 the Fogg held another one-man Degas exhibition, for which Paul Sachs would be the eminence grise; he supervised an exhibition organized by students in his Museum Course. Over the coming decades, student-run shows would become the main instructional device of the course, but in 1931 it was an innovation. They were specifically loan shows so that the students would have the experience of requesting works and arranging for their transport and insurance, as well as writing the catalogues and hanging the galleries. The kind of letter the professor hoped his protégés would write is suggested by

Fig. 33
AFTER THE BATH, WOMAN DRYING HER HAIR,
c. 1893–98
(no. 42)

a memorandum that John Coolidge wrote in 1961 to the student organizers of yet another Degas exhibition (which also included works by Ingres): "Draft letters to donors as if from you to an old friend—not as if from an old maid school marm to a particularly irritating pupil."[114]

Note the slip of the pen: Coolidge wrote "donors" for "lenders," and there is no doubt that the student exhibitions in particular were intended to sharpen a lender's appreciation for their special value in a university museum. For the 1931 Degas exhibition Sachs himself wrote several letters requesting loans, perhaps because the pictures were owned by old friends such as Samuel Lewisohn, who might have thought it odd to hear from someone else writing on Fogg letterhead.

There is not room in this essay to enumerate all of the subsequent special exhibitions at the Fogg that contained works by Degas, but one more instance of Degas drawings installed in its galleries should be mentioned. When in the 1932 Museum Course Sachs outlined his plans for a loan show of the Carle Dreyfus sculpture collection, unexpectedly offered by the dealer Joseph Duveen, he said he would install it in "the large Tintoretto Gallery on second floor, also [the] Rembrandt cubicle and Degas room."[115] These were installations of the Museum's permanent collection, together with in-house loans from the director, the associate director, and their families. (The Tintoretto, later to be given to the Fogg, was owned by Sachs's mother. His brother Arthur would later be instrumental in the 1940 acquisition of the Degas drawing *Half-Length Study of a Woman* [fig. 32].[116]) The "Degas room" may have included Paul Sachs's three new late Degas bathers (figs. 9, 33, 74). Evidently, by 1932 a roomful of works by Degas—perhaps even of the most radical kind—was entirely acceptable as the customary "hang" alongside the old masters. When the Dreyfus collection left the premises, an exhibition of "Degas and other French artists" was installed.[117]

Over the decades, students of Paul Sachs and Agnes Mongan, and also those who wrote their theses under Frederick Deknatel and John Coolidge, populated museums and art history departments across the nation, and it was not just Degas exhibitions at the Fogg that would have their sources and consequences at Harvard. From the beginning, Sachs lent his Degas works frequently. As Mongan wrote in her entry on *Young Woman in Street Costume* in the Sachs memorial catalogue, "The drawing, one of the best known and most beloved of Paul Sachs's drawings, has figured in some exhibition almost every year since he acquired it" (fig. 39).[118]

Fig. 34
HEAD OF A MAN, 1858
(no. 56)

Museum Course students bought major works by Degas for themselves or, if not personally wealthy, for their institutions, and featured them in loan exhibitions. The 1936

Philadelphia exhibition organized by Henry McIlhenny has already been mentioned, but even earlier, in 1933, Jere Abbott, who through Sachs's warm recommendation had become director of the Smith College Museum of Art in 1931, centered a monographic Degas exhibition around Smith's new acquisition *The Daughter of Jephthah* (fig. 13).[119] For his show Abbott borrowed a painting from the Fogg and five drawings from Sachs, including *Young Woman in Street Costume*.

The tradition continued even after Sachs's retirement, with a new emphasis on scholarship and publication. Just as one student, Eugenia Parry (Janis), broke scholarly ground with her exhibition and catalogue raisonné of Degas monotypes in 1968, which were based on her dissertation research, so another, Charles W. Millard, who completed his doctoral thesis on Degas sculpture in 1971, would first present his research to the public in an exhibition at Dallas in 1974, and would publish a catalogue raisonné of the sculpture two years later. Two further print exhibitions were organized and their catalogues written by Harvard-trained scholars, in both cases for academic museums. At the University of Chicago in 1964, Paul Moses showed Degas etchings; at Washington University in St. Louis in 1967, William M. Ittmann showed Degas lithographs.

In the preface to the sculpture catalogue, Millard gave full credit to a Fogg staff member who was carrying on traditions founded at the Museum not by Sachs but by Edward Forbes: "Luckily, Arthur Beale of the Fogg Museum's conservation laboratory was both at hand and interested in these [technical] issues and agreed to undertake an investigation of them in relation to the Degas waxes."[120] In their personal collecting specialties, Sachs acquired drawings, Forbes acquired artist's materials (as well as Italian quattrocento paintings). One taught connoisseurship in the Museum Course, the other taught the methods of the old masters in his equally famous "egg and plaster" course. For the "new" Fogg in 1927, Forbes designed the first modern conservation facility, and he hired the first conservation scientist in America, Rutherford J. Gettens, the next year. His true monument in the Art Museums today is not its art collections but its Straus Center for Conservation and Technical Study, with its focus on the scientific analysis and technical examination of works of art. As early as 1925, Alan Burroughs had approached Forbes about the usefulness of X-rays in the study of paintings, and it was that examination technique in particular that would prove so useful to Beale in his study more than forty years later of Degas's original wax sculptures and their casting into bronze.[121]

Two major exhibitions arranged two decades apart by one of the greatest Degas scholars ever trained at Harvard University have had special significance for the Art Museums. In 1967, coinciding with the print exhibition at Washington University, Jean Sutherland Boggs organized a traveling exhibition of Degas drawings. A major supporter of the

Fig. 35
DANCERS, NUDE STUDY,
1899
(no. 52)

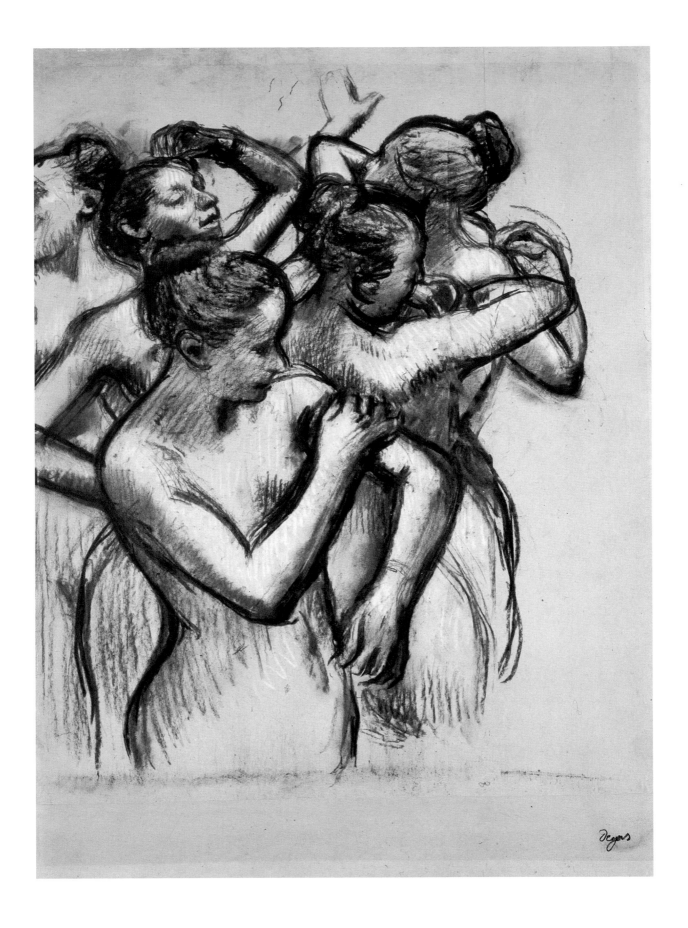

museum, Joseph Pulitzer Jr., Class of 1936, had been collecting since he was an under-graduate, when he had shown a photograph of a Modigliani painting then on the market to Paul Sachs. Sachs asked Pulitzer whether he could afford it, and when he said he could, Sachs advised him to buy it. Barely out of school, Pulitzer, like Maurice Wertheim, would make a purchase at the "Degenerate Art" auction in 1939, in his case not a post-impressionist portrait but a huge, emphatically twentieth-century Matisse. Yet although his growing collection soon also included late nineteenth-century art, Pulitzer owned no Degas works until he saw them in quantity on exhibition in 1967. He almost immediately purchased four, two of which are now committed to Harvard (figs. 34, 35). In the words of Emily Rauh Pulitzer, who in 1967 was the exhibition's coordinating curator at the St. Louis museum (and who was formerly an assistant to Agnes Mongan and later Pulitzer's wife), "[I]t was the most direct influence of an exhibition I had ever witnessed."[122]

In 1988 Boggs organized an even more important Degas exhibition, an all-encompassing survey that traveled to three international venues. James Cuno, who had been a graduate student at Harvard and was already familiar with the Degas works in the Fogg Art Museum, saw that show.

> I was just blown away by the size, quality, range of media, and relentless experimentation of his work. I thought that had I been an artist seeing that show, I'd have given it up: there'd be no room for me or my work in the universe of art making, so much of it did Degas already occupy. Fortunately, I wasn't an artist. I was a young teacher . . . and got to think and lecture about Degas and that helped me a lot. By the time I came back to Harvard, I had thought some more and it was by teaching Impressionism (and finding myself constantly caught up by Degas) and by looking at the Fogg's great holdings, that I thought of teaching a course on Degas.[123]

Cuno came back to Harvard as the director of its Art Museums. Despite his administrative duties, he was determined to teach, and Degas was his chosen subject. He was also determined to mount an exhibition of Harvard's resources in Degas. Although Cuno has left, his vision has remained with many of us who worked with him. And as our exhibition project progressed, it inspired yet more Harvard men and women to generous donations of paintings, drawing, and prints by Degas. Indeed, barely in time to meet our catalogue deadline, we have learned that a compelling oil on panel—our first Degas of this genre—will enter the collection: *Horses and Riders on a Road* (fig. 36). The Degas of Ross, Sachs, and Mongan remains, and he has been joined by so many more. Professors, curators, donors, students—each has his or her Degas at Harvard. Each and all have formed a heritage worthy of our celebration.

Fig. 36
HORSES AND RIDERS ON A ROAD, 1867–68
(no. 8)

NOTES

Unless otherwise indicated, all manuscript and unpublished material is in the Harvard University Art Museums Archives (HUAMA) and is here published with the permission of the director of the Art Museums. Letters will be found in the files of the in-house correspondent, e.g., letters to and from Paul Sachs will be found in the Sachs correspondence files. If correspondence or other documents refer to specific exhibitions, they may be located in the exhibitions' files. I would also like to thank the Harvard University Archives (HUA), the Schlesinger Library, Radcliffe Institute, and the Grolier Club for their permission to quote from manuscript material in their collections.

The abbreviation "L." refers to the number for paintings and pastels in the Degas catalogue raisonné: Paul-André Lemoisne, *Degas et son oeuvre* (Paris, 1947–48).

1 Paul J. Sachs, "Tales of an Epoch" (undated typescript), 3:252.

2 Sachs to Henry P. McIlhenny, September 26, 1933. See n. 91 for more information on this drawing, *The Ballet Master*.

3 Sachs to McIlhenny, January 30, 1936. Actually, McIlhenny's mother purchased it at her son's request, on January 27, 1936. See McIlhenny to Sachs, January 28, 1936, and the record of the Fogg Museum registrar (6.1936), which records the deposit of the painting from M. Knoedler and Co. from January 11 until January 23, 1936.

4 The dates of the exhibition were April 5–14, 1911. There is no reason to think Degas ever learned of the exhibition; had he, he would have disapproved. See the outraged letter he wrote in 1899, refusing to participate in exhibitions not under his control, in Edgar Degas, *Lettres de Degas*, ed. Marcel Guérin (Paris, 1945), 227; see also Richard Kendall, *Degas: Beyond Impressionism*, exh. cat., National Gallery (London, 1996), 39–49, 294–95, and Marilyn R. Brown, *Degas*

and the Business of Art: A Cotton Office in New Orleans (University Park, Pa., 1994), 120–21, for where, when, and under whose auspices work by Degas was exhibited in the late nineteenth and early twentieth centuries.

5 See Edward Waldo Forbes, "History of the Fogg Museum of Art," 5th rev. (typescript, c. 1955), 1:95.

6 Museum of Fine Arts, *Handbook* (Boston, 1910). In the various editions, the text under the Degas reproduction never varied, but the running head changed from "French" in 1907 to "Modern Rooms" in 1910 and then back to "French" in 1916. This may have represented a rehanging of the galleries.

7 Before it was acquired by Maurice Wertheim, it was exhibited at the Fogg again in 1919, 1939, and 1941.

8 Letter from Forbes to Adams Express Co., April 8, 1911. Forbes's letter to Frank Macomber, April 4, 1911, gives the painting's insurance value at the time: $20,000.

9 A[rthur] P[ope], *A Loan Exhibition of Paintings and Pastels by H. G. E. Degas*, exh. cat., Fogg Art Museum (Cambridge, 1911), 1; and Boston *Advertiser*, April 6, 1911, clipping in Fogg Museum Scrapbook, 1:28 (HUAMA). The newspaper article, also signed A. P., essentially reproduces the exhibition brochure's text.

It has proven impossible to identify the reproductions and photographs lent by the Museum of Fine Arts, although probably these included a portfolio published with Degas's approval. *Vingt Dessins*, 1861–96, is a set of twenty collagraphic reproductions of Degas drawings, published by Goupil & Cie, Paris, c. 1897, with Degas's collaboration; each portfolio was signed by the artist. One of the sets owned by the museum is matted up, as if for exhibition, but it is not accessible for examination today. The set in the Fine Arts Library (formerly in the collection of the Fogg Art Museum Library) was given by Paul Sachs and is now incomplete; the reproductions of two of his most famous Degas drawings are missing from it (figs. 8, 39). Presumably they were taken out to compare with the originals in classes and never found their way back to the library.

In a letter of April 8, 1911, Edward Forbes declined to include in the exhibition a painted copy of a Degas, offered by Mrs. F. M. Greene, 5 Avon Street, Cambridge.

10 Boston *Transcript*, April 7, 1911, clipping in Fogg Museum Scrapbook, 1:29. F. W. Coburn had written in his "Saturday Saunterings" the previous January, "'Lost in the Fogg' might truthfully be said of many a noble work consigned to the cross lights and half-lights of the academic museum that is situated opposite Memorial Hall in Cambridge" (Boston *Herald*, January 7, 1911, clipping in Fogg Museum Scrapbook, 1:25). Alfred Pope was a good friend of the Fogg. In 1913 he gave $12,000, the total sum necessary to renovate the "old" Fogg. Renovations included a redesign of the skylights, so that light fell on the gallery walls. The "old" Fogg was succeeded by the present structure on Quincy Street in 1927, and the building was eventually replaced by Canaday Hall, a freshman dormitory.

11 See Jean Sutherland Boggs et al., *Degas*, exh. cat., Galeries Nationales du Grand Palais, National Gallery of Canada, Metropolitan Museum of Art (New York, 1988), 198. According to Emily Rauh Pulitzer, Agnes Mongan said that the frames of the Fogg's three late bather drawings (figs. 9, 33, 74)—all original frames—were rubbed down in the 1930s because they were too white and bold (Pulitzer to the author, December 2, 2004).

12 H[oratio] G. Curtis to Forbes, April 11, 1911.

13 Forbes to Curtis, April 12, 1911. Forbes gave this attendance figure to Denman W. Ross in a letter two years later (March 25, 1913), reporting on an exhibition of the work of J. M. W. Turner that was almost as popular.

14 Edward Waldo Forbes, "The Relation of the Art Museum to a University," *Proceedings of the American Association of Museums* 5 (1911): 53–55.

15 Denman W. Ross, letter to the *Harvard Crimson*, April 5, 1911, clipping in Fogg Museum Scrapbook, 1:28.

16 A. J. Philpott, "Paintings by Degas," Boston *Globe*, April 10, 1911, clipping in Fogg Museum Scrapbook, 1:30.

17 Boston *Transcript*, April 7, 1911, clipping in Fogg Museum Scrapbook, 1:29. The painting was titled *Le Viol (The Rape)* in the first published monograph on Degas (Paul-André Lemoisne, *Degas* [Paris, 1912], 61–62).

18 This was recorded by the dealer René Gimpel in his diary entry for May 9, 1921. In 1931 Gimpel appended a note that the painting was then in Philadelphia (René Gimpel, *Diary of an Art Dealer*, trans. John Rosenberg [New York, 1987], 164). The second of these dates is an error and the first may be also: the painting was lent for exhibition at Boston only in 1935 and entered the McIlhenny collection in Philadelphia only in 1936. It was on approval earlier that year at the Fogg; perhaps Paul Sachs showed it to members of the Museum of Fine Arts purchase committee there.

19 Julius Meier-Graefe, *Modern Art, Being a Contribution to a New System of Aesthetics,* trans. Florence Simmonds and George W. Chrystal (New York, 1908), 1:280.

20 Bryson Burroughs, "Introduction," *Loan Exhibition of Impressionist and Post-Impressionist Paintings*, exh. cat., Metropolitan Museum of Art (New York, 1921), vii–viii, x.

21 Forbes to Sarah Choate Sears, March 31, 1911. Sears's friend Mary Cassatt (who was Degas's friend) gave her a box of pastels; see Erica E. Hirshler, *A Studio of Her Own: Women Artists in Boston, 1870–1940*, exh. cat., Museum of Fine Arts (Boston, 2001), 55–62. This catalogue reproduces one of Sears's own brilliantly colored, broadly worked pastels. The Fogg Museum holds a number of photographs by Sears; she was elected a member of Alfred Stieglitz's Photo-Secession group in 1904. Her collection also included works by Manet and Cézanne. She would purchase four more works by Degas.

22 Sears to Forbes, undated [April 7, 1911].

23 Meier-Graefe, *Modern Art*, 1:280.

24 In his memoirs, Forbes remembered, "Once in a while, in the years before 1901, I used to go with enthusiasm to see Mr. Quincy Shaw's collection of Millets and other works of art" (Forbes, "History," 1:46).

25 Sally Anne Duncan, "Paul J. Sachs and the Institutionalization of Museum Culture between the World Wars" (Ph.D. diss., Tufts University, 2001), 373, quoting Otto Wittman, who studied under Pope in 1929–30. Agnes Mongan described Pope as a lecturer as "very gentle and, I can't say slow, but quiet" (Agnes Mongan, "Interview: Agnes Mongan Talks with Paul Cummings," *Drawing* 4, no. 4 [1982]: 84). Sachs appreciated Pope's teaching because "He was the first to use constantly in classroom teaching the wealth of original material available at the Fogg" (Sachs, "Tales," 2:170). Although Pope (and Ross) disapproved of Forbes's purchase of a Burchfield watercolor in 1933, in 1948 he urged the Fogg to buy Matisse's *Jazz* (Forbes to Sachs, March 3, 1933; John P. Coolidge, undated conversation with the author).

26 Forbes to Pope, October 9, 1917.

27 The drawing was bought from M. Knoedler in New York for $8,500. For the complex history of the print, see Marjorie B. Cohn, "William Ivins's Taste in Prints," *Print Quarterly* 22, no. 1 (2005), 39–40. Sachs bought from P. and D. Colnaghi in London a major drawing by the preeminent German printmaker Albrecht Dürer, *Susannah of Bavaria*, which he had seen in London and reserved in 1918, during the war, but did not purchase until 1920 when Colnaghi reminded him that they were still holding it for him. For this history and an overview of the artworks given and bequeathed by Sachs to the Fogg Art Museum, see *Memorial Exhibition: Works of Art from the Collection of Paul J. Sachs*, exh. cat., Fogg Art Museum and Museum of Modern Art (Cambridge, 1965).

28 Sachs, "Tales," 1:53–54.

29 Ann Dumas et al., *The Private Collection of Edgar Degas*, exh. cat., Metropolitan Museum of Art (New York, 1997), 132.

30 Sachs to Ross, March 31, 1921.

31 Agnes Mongan, "Introduction," *Memorial Exhibition*, 10.

32 See Gimpel, *Diary*, 21–22, and Dumas, *Private Collection*, 264.

33 William M. Ivins, Jr., to Sachs, May 14, 1921. The "head" was insured for $500. That the artist, now dead, was beginning to recede to the status of old master is suggested by his work being shown together with the three drawings by a living artist, Picasso, which were also lent by Sachs. List of drawing loans by Sachs to the Metropolitan Museum of Art, May 12, 1921 (in Sachs–Ivins file). The only other drawings Ivins mentioned in his letter were the Picassos; he said that Arthur B. Davies liked them. In 1932, in her first publication on Degas, Mongan wrote that the artist "is the only Old Master—for such he has become a scant fifteen years after his death." Agnes Mongan, "Portrait Studies by Degas in American Collections," *Bulletin of the Fogg Art Museum, Harvard University* 1, no. 4 (1932): 62.

34 Sachs, "Tales," 4:327; Sachs to Henri Focillon, March 26, 1934.

35 Sachs to Focillon, April 25, 1934.

36 Focillon to Sachs, April 27, 1934 (translation mine).

37 Paul J. Sachs, "Extracts from Letters of Henri Focillon," *Gazette des Beaux-Arts*, 6th ser., 26 (July–December 1944): 11–12. Sachs and Focillon both would have read Edmond Duranty's essay *The New Painting* (Louis Emile Edmond Duranty, *La nouvelle peinture à propos du groupe d'artistes qui expose dans les galleries Durand Ruel* [Paris, 1876]), which may record the actual words of Degas. In 1876 Duranty wrote about the new realism: "[I]t is the study of states of mind reflected by physiognomy and clothing, the relationships of a man to his apartment, of the particular influence of his profession on him, as reflected in the gestures he makes: [the observation] of all aspects of the environment in which he evolves and develops. A back should reveal temperament, age, and social position, a pair of hands should reveal the magistrate or the merchant. And a gesture should reveal an entire range of feelings" (as translated in Brown, *Degas*, 77).

38 Focillon to Sachs, May 13, 1939. "Il est de la légacé [in his *Gazette des Beaux-Arts* transcription, Sachs wrote "ligne"] de Saint Edgard Degas [the second "d" was omitted in the transcription]. Nous pourrons l'inscrire au nombre des

membres de la *S.S.B. (Seraphic Sensuality* Brotherhood), dont vous serez le grand-maître." The underlining was by Sachs.

39 Agnes Mongan, "Interview," Anne A. Meyer, interviewer (Cambridge, 1991), 40 (typescript, Schlesinger Library, Radcliffe Institute).

40 The year of purchase is deduced from the date of their deposit at the Fogg Museum. At this point in Sachs's collecting career, acquisitions as expensive and physically large as these would probably have been sent to the museum.

41 The sculpture was by the Italian mannerist Pietro Francavilla. In 1932 a female Museum Course student and instructor at Radcliffe College, Bertha H. Wiles, published an article on it in the *Bulletin of the Fogg Art Museum* (1, no. 4 [1932]: 65–72). The same year the sculpture was sent from the Fogg to the Wadsworth Atheneum, where it was acquired and installed by Atheneum director A. Everett Austin, a former student of Sachs. Correspondence between Sachs and Austin implicates Forbes in its rejection at the Fogg. See Kathryn Brush, *Vastly More than Brick and Mortar: Reinventing the Fogg Art Museum in the 1920s* (Cambridge, 2003), 76–77.

42 Richard Wilbur to the author, November 29, 2004.

43 Quoted in Daniel Halévy, *My Friend Degas*, trans. Mina Curtiss (Middletown, Conn., 1964), 24–25, n. 1.

44 The memory of the hat and veil was evoked by Eugenia Parry, the gloves by Eunice Williams, but as a graduate student and young employee in the 1960s I also often experienced Mongan's conservative attitude toward dress. Her model in this, as in so much, was Sachs, with his "lifelong obsession with proper, spit-and-polish attire" (Duncan, "Paul J. Sachs," 120, n. 5).

45 As an example of Bowers's role in Sachs's life, a conciliatory letter from Sachs to Bowers, March 23, 1923, suggests that Bowers was alarmed by the accelerating purchases of drawings and the drain of money from his friend's account: "Furthermore as you doubtless know from Arthur [Arthur Sachs, Paul's brother], I am as quickly as pressure of other duties permits,

weeding my collection and in so doing I shall realize a certain amount of cash without weakening the collection as a whole, in fact the process is likely to strengthen it, for of course I am disposing not of the great things, but of the material of a purely secondary nature which has served its purpose in my personal training."

46 Alfred H. Barr, Jr., to Sachs, March 27, 1943.

47 Sachs to Pope, January 6, 1921; Forbes to Pope, December 18, 1920.

48 The testiness of Sachs's correspondence with Durand-Ruel, from whom he was acquiring the two Degas drawings, suggests some embarrassment at the payment plan.

49 Sachs to Forbes, December 27, 1932; January 1, 1933.

50 Sachs to Forbes, January 10, 1933; January 13, 1933; January 22, 1933.

51 Forbes to Sachs, January 23, 1933.

52 Forbes to Sachs, January 28, 1933.

53 Sachs to Forbes, February 5, 1933.

54 Sachs to Forbes, February 12, 1933.

55 Hope for the Fogg and resignation to the Museum of Fine Arts was an old story. On November 23, 1926, Joseph Durand-Ruel wrote to Sachs: "According to your instructions, we are shipping to you . . . the painting by Degas, la calèche (la voiture aux courses). . . . The net price is $40,000" (fig. 43). Sachs cabled Durand-Ruel on December 15, 1926: "We greatly regret that we shall not be able to keep your beautiful Degas as we have been unable to find the money Stop Are you willing that we should deliver the picture to the Museum of Fine Arts . . . as the Boston Museum would like a chance to try and buy it since we have failed Stop."

56 See the Sachs–Herbert N. Straus correspondence file and also the letter from Felix Wildenstein to Sachs, March 9, 1929: "[O]ur very best price for the 'Cotton Exchange,' by Degas, is $8500.00."

57 C. Chauncy Stillman to Sachs, March 25, 1925. Stillman pledged to Sachs that he would change his will to the Fogg's benefit, but he died in 1929 after a mid-Atlantic appendectomy and before signing the appropriate documents. Sachs was "pretty blue at the outcome of the Stillman affair," as he said to Felix Warburg, yet another good friend in the New York banking world, "and felt that perhaps we should never again find anyone as deeply interested in the happenings of the Fogg Museum as Stillman undoubtedly was, with the exception of you and Forbes and myself" (Sachs to Felix Warburg, May 21, 1927). Warburg's son Edward, Class of 1930, who was a student of Sachs and became a close friend of Agnes Mongan, being more of her generation, gave a Degas sculpture to the Fogg in 1960 (fig. 51).

58 See Ann Dumas and David A. Brenneman, *Degas and America: The Early Collectors*, exh. cat., High Museum of Art, Atlanta, and Minneapolis Institute of Arts (New York, 2001), 189, for details of the painting's provenance.

59 Forbes to Sachs, November 8, 1932.

60 For further information on Grenville Winthrop and his collection, see Stephan Wolohojian, ed., "A Private Passion," in *A Private Passion: 19th-Century Paintings and Drawings from the Grenville L. Winthrop Collection, Harvard University*, exh. cat., Metropolitan Museum of Art and National Gallery, London (New York, 2003).

61 The official name of this course was "Seminar on Museum Work and Museum Problems," but in correspondence and conversation it was always shortened to "Museum Course." See Duncan, "Paul J. Sachs," for a complete history and analysis of the course.

62 Sachs to Pope, June 26, 1929.

63 Sachs to Philip Hofer, January 23, 1934.

64 In 1940 Hofer deposited two Degas drawings at the Fogg, *Cellist* (772.1940) and *Ballet Dancer* (809.1940). He acquired the landscape monotype (fig. 24) in 1968, probably under the inspiration of the Museum's definitive Degas monotype exhibition, where it was on loan from R. M. Light and Co., the Boston dealer from

whom he bought it. Hofer was, nevertheless, one of the greatest donors of works of art, manuscripts, and books to Harvard in its history, and undoubtedly the Degas drawings he sold have enriched its collections through their value, enabling him to buy other works that he gave or bequeathed to Harvard.

65 Sachs to John S. Newberry, January 8, 1932.

66 Sachs to Forbes, January 22, 1933.

67 Sachs to Newberry, July 12, 1933.

68 Forbes to Sachs, April 6, 1933.

69 Mongan, "Interview" (1991), 12. In another interview, Mongan identified the current residents as M. and Mme Lerch (Mongan, "Interview" [1982], 84–85). Their name may have been spelled Lerche. See Degas, *Lettres*, 120, 202, 203, for letters that specify "Mardi" as his usual day for dinner with Alexis Rouart. It was at the Rouart home that Degas created his etching *Leaving the Bath* when an ice storm had prevented him from leaving after dinner (see Degas, *Lettres*, 61, n. 1). The impression of this print in the Fogg collection was formerly in the collection of Alexis Rouart, and was undoubtedly the gift of the artist (fig. 77). Rouart did not, however, live at the address specified by Mongan. Another family with whom Degas was close, that of Ludovic Halévy did live there, and until the rupture of their friendship over the Dreyfus Affair, Degas dined with the Halévys on Thursdays. See Degas, *Lettres*, 218–19, for letters that specify "Jeudi" as his day for dinner with the Halévys, and see *Entre le théâtre et l'histoire: La famille Halévy (1760–1960)*, exh. cat., Musée d'Orsay (Paris, 1996), 155, for photographs of 22 rue de Douai. Mongan or perhaps the Lerches simply had mistaken the day of the week. Degas created a suite of monotypes to illustrate Halévy's novelette about the Cardinal family; Sachs purchased one of the best of them (fig. 82).

70 Quoted in Mongan, "Interview" (1982), 83.

71 Mongan, "Interview" (1991), 22, 36–37.

72 Sachs to Durand-Ruel, April 29, 1919.

73 Durand-Ruel to Sachs, November 10, 1919.

74 Sachs to Durand-Ruel, November 13, 1919. In his memoirs Sachs wrote: "A connoisseur-curator must have available, in addition to a well-chosen library, large numbers of carefully selected, up-to-date photographs to enable him to make comparisons of objects as an aid to scholarship. But in order to keep his instincts, his sensibility, razor-sharp, *he must also each day study originals*" (Sachs, "Tales," 4:371, emphasis in the original).

75 Sachs to Ivins, July 2, 1927.

76 Agnes Mongan and Paul J. Sachs, *Drawings in the Fogg Museum of Art*, 2nd ed. (Cambridge, 1946), 356.

77 Mongan to Jean Sutherland Boggs, June 28, 1988.

78 McIlhenny to Mongan, June 18, 1935; July 22, 1935; June 19, 1936 (HUA, Box No. 12905 2/3); McIlhenny to Sachs, September 10, 1936; Sachs to McIlhenny, October 10, 1936.

79 Sachs, "Tales," 1:49.

80 Sachs to Marcel Guérin, September 14, 1936. Guérin was chairman of Les Amis du Louvre, the support organization that in 1933 purchased the Degas painting *Lorenzo Pagans, Spanish Tenor, and Auguste De Gas, Father of the Artist*, which Sachs had dreamed of for the Fogg (fig. 16).

81 All four photographs owned by Guérin and included in the Philadelphia exhibition were received by the Museum, but the only two that seem to have survived are the two landscapes now in the Fogg Museum's collection. See the essay by Boggs in this catalogue for their earlier and until now unrecorded presence in a Fogg curatorial department. The other two have not been located in the library and may be lost.

82 André Weil to Sachs, November 29, 1946. This letter and all other correspondence concerning the painting are in the Sachs–Guérin file.

83 Sachs to André Weil, December 9, 1946.

84 Arthur K. Solomon, "Arthur Kaskel Solomon; Transcript of Interviews Sponsored by the Oral History Committee, Harvard Medical School, 1993–1995. Part I. Interview with Robert Kohler. Part II. Interview with Angela Creager. Part III. Interview with Marjorie B. Cohn." (Boston, 1997; transcript in HUAMA), 1:17.

85 Arthur K. Solomon to Sachs, April 23, 1939.

86 Solomon, "Interviews," 3:382–83.

87 Temporary loan TL5148, received January 25, 1940, converted to long-term loan 754.1942. The Nazis invaded France in May 1940. Valland was deeply involved in the logistics of transport of artworks from Paris museums when threatened by the war and then in the Nazi confiscation of French artworks, since the Jeu de Paume became a depot for collection and transshipment. See her book *Le Front de l'art: Défense des collections françaises, 1939–1945* (Paris, 1961). She is considered a heroine in France; there is a society and website dedicated to her memory: www.rosevalland.com.

88 After Pearl Harbor, Sachs wrote to a number of museum directors in locations relatively far from major East Coast cities, asking if they had appropriate storage areas and were willing to receive works of art from the Fogg. Almost all of them (many his former students) were warmly receptive. There was a personal link with Rosenwald, a print collector whom Sachs had known for years: his curator was Elizabeth Mongan, Agnes's sister. See the two "Air Raid" folders in HUAMA for information on wartime precautions and the evacuation of art from the Fogg. The only Degas to which Sachs gave a higher valuation was his *Young Woman in Street Costume*, valued at $6,000 in 1936 when he lent it to the 1936 exhibition in Philadelphia; he valued the *Ballet Dancer* at $4,500 at that time, also.

89 Drawing *à l'essence* is a technique whereby pigments are carried by turpentine or other solvents onto the page, creating a painterly appearance.

According to the Fogg registrar's records, *Au Café de Châteaudeu* was returned in December 1943 (and was sold by Dumbarton Oaks to raise funds for Byzantine acquisitions in 1966); the other two were returned in October 1944.

A letter from McIlhenny to Sachs (February 23, 1933) indicates that as an undergraduate he had considered purchasing the study of Giulia Bellelli but was scared off by its price.

90 Sachs to Thomas N. Metcalf, February 10, 1942; April 23, 1943.

91 The *Duranty* facsimile is no. 42 in Henri Rivière, *Les Dessins de Degas réproduit en facsimile* (Paris, 1922–23). "McIlhenny . . . recalled having seen [*The Ballet Master* (L. 364)] 'in that group of facsimiles which Sachs went over in detail one night I was there for dinner. I remember distinctly his anger at not having bought it when he had the chance because he considers it one of the top-notch drawings'" (Dumas, *Degas and America*, 28). The only other facsimile in the portfolio that reproduces a drawing at that time in an American museum collection is no. 60, *Study for "Woman Seated beside a Vase of Flowers"* (fig. 5 herein). Its owner is given as "Fogg Art Museum. Collection Sachs."

92 *Bulletin of the Fogg Art Museum* 10 (November 1943): 55; *Harvard Alumni Bulletin* 46, no. 7 (1944): n.p.; Agnes Mongan, "Before and after Impressionism," *Art News* 42, no. 16 (1944): 22. In the *Alumni Bulletin*, sixteen Winthrop artworks were reproduced in color, and Mongan was credited for this novelty: "Without her assistance and intuitive good taste, this four-color departure could not have been undertaken." Of the sixteen, which included Asian as well as European and American works, two were by Degas—the only artist represented by more than one.

93 Eugenia Parry to the author, October 22, 2004.

94 Eugenia Parry Janis, *Degas Monotypes: Essay, Catalogue, & Checklist*, exh. cat., Fogg Art Museum (Cambridge, 1968).

95 Sachs to Forbes, March 11, 1933. The other prospects were Philip Hofer, John Nicholas Brown, Charles Bain Hoyt, and John Walker. Brown, Class of 1922, had lent three Degas drawings to the 1929 French painting exhibition at the Fogg, and Mongan courted him with an exhibition of his drawing collection in 1962. In the catalogue preface she wrote: "The owner makes a graceful gesture in sending his drawings to Cambridge, to the place where his inborn taste and natural understanding were nurtured and developed. It is startling to realize that as recently as thirty to forty years ago a young man with a sensitive eye, sure knowledge and eager acquisitiveness could find and purchase such drawings as . . . the superb selection by Degas." Mongan, *Forty Master Drawings from the Collection of John Nicholas Brown*, exh. cat., Fogg Art Museum (Cambridge, 1962), n.p.

96 Mongan, "Interview" (1982), 86.

97 Agnes Mongan, "Introduction," *Loan Exhibition: Selections from the Drawing Collection of David Daniels*, exh. cat., Fogg Art Museum and Minneapolis Institute of Arts (Cambridge, 1968), 8–9. Daniels, though not a Harvard man, was actively courted by Mongan; his drawing collection contained several by Degas, including landscape pastels of the sort that are not even now in the Fogg collection. In the catalogue preface, Mongan wrote, "There is one other trait that David Daniels shares with Paul Sachs, one that would have particularly delighted that famous teacher and collector: a natural generosity and readiness to share with others the joy his treasures afford" (p. 10).

98 I am one staff member, Eunice Williams is another, who remembers Mongan's cautionary report of the changed will and these telephone calls. On December 2, 1947, Newberry had written to Sachs, "I hope to have a moment with you, among other things to discuss a question in connection with my will and what I am planning to do as regards the Fogg Museum." Those plans are not known, but in a will written in 1957, Newberry bequeathed to Harvard, apparently at Mongan's suggestion, an endowment "for the study of drawings in connection with the Fogg Museum" (terms of the John S. Newberry Fund, an endowment received in 1965; see the undated memorandum from Mongan to John Coolidge referring to a letter from Newberry, July 3, 1957). His lifetime gifts to the Fogg also included a major Cuyp drawing given in honor of Sachs's seventieth birthday, a de Wint watercolor given in honor of Mongan's mother, and a number of lesser prints and drawings. He also contributed to the Paul J. Sachs Galleries in the Museum of Modern Art. Henry McIlhenny gave a Beccafumi drawing to the Fogg the year he graduated from college and a Cézanne watercolor in 1957 (see below); he also funded the purchase of some Gillot drawings and gave several pieces of German sixteenth-century stained glass to Harvard's Busch-Reisinger Museum.

99 Mongan to Thacher, February 19, 1970. This letter also tells us more about the gift from McIlhenny of a Cézanne watercolor to the Fogg in 1957: "[W]hat a magnificent watercolor that Cezanne is [Thacher's Cézanne] and how wonderful of you to promise it in memory of Paul Sachs. . . . When he sold the lovely *Mont Sainte Victoire* to Henry, I think he regretted it and was very happy when Henry promised it back. Beautiful as Henry's watercolor is, yours is, I think, even more smashing."

100 Mongan to Boggs, September 17, 1985. During his lifetime Thacher made a few minor gifts to the Fogg, often together with Charles Bain Hoyt.

101 Forbes, "History," 2:357.

102 McIlhenny to Sachs, December 13, 1946.

103 Sachs to Newberry, May 25, 1949. Yet on January 29, 1955, in a little notebook in which Mongan recorded every interesting drawing that she saw at dealers and private and museum collections, she noted at the Charles Slatkin Gallery, "Degas *Self-Portrait* crayon $1800 PJS" (HUA Box No. 12905 2/3). This is the only record over the period covered in the notebook, 1955–56, in which she indicated a possible purchaser for a drawing.

104 Maurice Wertheim to Sachs, May 13, 1949.

105 Sachs wrote to Arthur Pope on May 4, 1921, on the occasion of the modern painting exhibition at the Metropolitan: "They have staged a perfectly wonderful show of Impressionist and Post-Impressionist pictures, and of course I could not help feeling just a little satisfaction at the thought that the little Fogg Museum had shown Degas, Cezanne, etc., before the big Metropolitan has now followed suit. Furthermore, the Metropolitan has broken its rule on this occasion and has borrowed pictures from dealers, though all those that come from dealers are lent 'anonymously.' So they have after all done just what we have done

for a number of years, only they haven't quite the courage, or perhaps consider it poor judgment, to add the name of the real lender."

Another Degas drawing was given to the Fogg by another dealer. *A Nude Youth Crawling: Study for "Young Spartans Exercising"* (fig. 54) is recorded as the gift of Mrs. Albert D. Lasker, but in fact when she gave the drawing in 1927 her name was Mary Woodard Reinhardt, and she was then in charge of modern art at the Reinhardt Gallery in New York. See Francine du Plessix, "Art and Flowers: Mrs. Albert D. Lasker," in Jean Lipman, compiler, *The Collector in America* (New York, 1970), 164: "She took several courses with Paul Sachs at the Fogg Art Museum, and this scholar's lectures fired her with a profound and lasting love for impressionism."

106 Sachs to Newberry, November 21, 1947. On September 6, 1933, Durand-Ruel had written to Sachs, "Thanks ever so much for sending us, with a letter of introduction, Mr. John S. Newberry, Jr, who is one of your admirers and who purchased a Degas drawing of the earlier period."

107 *French Painting Since 1870,* exh. cat., Fogg Art Museum (Cambridge, 1946). See John O'Brian, *Degas to Matisse: The Maurice Wertheim Collection* (New York and Cambridge, 1988), for a more recent catalogue of the collection.

108 Sachs, "Tales," 3:214.

109 Sachs to Charles B. Eddy, March 23, 1921.

110 Eddy to Sachs, April 25, 1921; Sachs to Eddy, April 27, 1921. In a letter to Sachs, April 20, 1921, Eddy said that six of the Pissarro prints had belonged to Degas. Through the Kennedy Gallery, Eddy lent thirteen Degas prints, including two pastel-monotypes, valued at a total of $10,000, to the 1922 Grolier Club Degas exhibition (typescript list courtesy of the Grolier Club). The relatively inexpensive valuation makes it obvious that Sachs could have formed an excellent collection of Degas prints had he wanted to.

111 Sachs to William Downes, undated [May 1921]; Boston *Evening Transcript,* May 9, 1921, the review signed W[illiam] H. D[ownes], clipping in Sachs–Eddy correspondence file.

112 *Exhibition of French Painting of the Nineteenth and Twentieth Centuries,* exh. cat., Fogg Art Museum (Cambridge, 1929). The catalogue preface was written by Arthur Pope.

113 See *Degas, 1834–1917,* exh. cat., Pennsylvania Museum of Art [Philadelphia Museum of Art] (Philadelphia, 1936), 12. Sachs requested that all of the artworks he bequeathed to the Fogg be listed with the credit line "Bequest of Meta and Paul J. Sachs," except for five, to be credited "Bequest of Paul J. Sachs, Class of 1900." Of these five, "On one of my modern drawings the words: 'A testimonial to my friend W. J.[sic] Russell Allen." A copy of the Sachs will is in the HUAM registrar's donor file. Picasso's *The Bathers* was chosen as the memorial to Allen, undoubtedly by Agnes Mongan.

114 *Ingres and Degas: Two Classical Draughtsmen, An Exhibition Prepared by Students in the Museum Course,* exh. cat., Fogg Art Museum (Cambridge, 1961); John Coolidge to Gretel Goldring [and] Students in Museum Course, March 16, 1961. Many of the loans to the 1931 Museum Course Degas exhibition were from dealers, and a copy of the catalogue in the HUAMA is inscribed with the prices of those pictures.

115 Duncan, "Paul J. Sachs," 210–11, n. 51, quoting Sachs, "M[useum] C[ourse] N[otes], Twenty-Second Meeting" (February 8, 1932), 134.

116 One of the more curious examples of Sachs's reliance on his family for financial support, both personal and institutional, is evidenced by the provenance of *Half-Length Study of a Woman* (fig. 32). It was acquired by the Fogg from Jacques Seligmann & Co., Inc., in January 1940 in exchange for a pair of andirons valued at $5,200 that had been presented to the Museum by Arthur Sachs, Paul's brother. Paul Sachs had owned the Degas drawing from at least 1929 till after 1936 and presumably had exchanged it for something else from Seligmann when short of cash. And presumably he had his brother's permission to swap the andirons for the Degas for the Fogg. Arthur Sachs owned several major works by Degas that did not come to the Fogg.

117 "Degas and other French artists of the nineteenth century. A small but important group of drawings and a few paintings, from the Museum and from private collections, March–June," *Bulletin of the Fogg Art Museum* 1, no. 4 (1932): 79.

118 Mongan, *Memorial Exhibition,* no. 58. Since then, the Art Museums have taken a more conservative approach to its loan, to preserve the tonality of the fragile sheet.

119 The exchange of letters between Sachs and Abbott in 1931, when Abbott was considering leaving his post as assistant director of the Museum of Modern Art to become director at Smith, is the single file in the Museums' archives most expressive of Sachs's personal devotion to his students and their advancement.

120 Charles W. Millard, *The Sculpture of Edgar Degas* (Princeton, 1976), xxi–xxii.

121 For more information about this aspect of Forbes's career at the Fogg Museum, see *Edward Waldo Forbes, Yankee Visionary,* exh. cat., Fogg Art Museum (Cambridge, 1971). Beale published some of his technical studies of Degas's sculpture in Richard Kendall, with contributions by Douglas W. Druick and Arthur Beale, *Degas and the Little Dancer,* exh. cat., Joslyn Art Museum, Omaha (New Haven, 1998). A historical note: Alan Burroughs was the son of Bryson Burroughs, the curator who had first dared show the work of living artists at the Metropolitan Museum of Art in 1921.

122 Emily Rauh Pulitzer to author, October 23, 2004.

123 James Cuno to author, December 22, 2004.

DEGAS, PROFESSOR SACHS, AND ME

JEAN SUTHERLAND BOGGS

S IXTY YEARS AGO—IN 1944 TO BE PRECISE—I went to Harvard to take the Museum Course.[1] I was twenty-two and had received an honors degree in the history of art at the University of Toronto and had worked for two years at what is now called the Montreal Museum of Fine Arts. Although I was young, I was determined to study at the Fogg Museum at Harvard. I had even heard the name of Professor Paul J. Sachs, who had developed the Museum Course there. I may have been a raw novice but I was intent upon undertaking that course, which might explain the mysteries of art museums to me. As a result I was to meet and come to respect Professor Sachs, who had graduated from Harvard forty-four years earlier.

Ironically, in growing up in Canada I knew almost nothing about Edgar Degas, the painter who would arouse my admiration for Professor Sachs and consume much of my professional life. If I had been a generation older I might have seen two great (and somewhat eccentric) works by this French artist, which had then been in Canadian private collections. In the Drummond collection in Montreal there had been the small and enigmatic canvas of an artist in the corner of his studio, seemingly cowering above the full-scale lay model of a dressed young girl collapsed beside him on the floor.[2] This canvas is now in the Gulbenkian Museum in Lisbon. In the Mulock collection in Toronto, I might have confronted the great version of *Mlle La La at the Cirque Fernando*, which is now in the National Gallery in London.[3] Both were sold before I was born, however, by the heirs of their Canadian owners who had been so perceptive in their acquisitions.

Curiously, in spite of the lack of originals by Degas to inspire us, my college roommate and I did buy small color reproductions of two related, very late, and more conventional works by this artist: a pastel of three dancers in blue and another, similarly composed, in oil in a warmer, rosier palette.[4] But I think of them as an anomaly. I do not believe that I gave them any serious consideration, although these reproductions did hang framed on our walls for something like four years. Professor Sachs was to change such casual indifference on my part to even such poor records of the work of Edgar Degas.

THE SONG REHEARSAL (detail), 1872–73 (fig. 46, no. 9)

Fig. 37
SELF-PORTRAIT, c. 1857–58.
Oil on paper mounted on
canvas, 26 x 19 cm. Sterling
and Francine Clark Art
Institute, Williamstown,
Mass.
(L. 37)

Although I fully realized from the beginning of my career at Harvard that Professor Sachs was a renowned connoisseur, collector, and benefactor, I am not sure that I recognized immediately that he was also a great teacher, who was a master of subterfuges. This impression may have been largely because he dispensed with many of the accoutrements of the conventional classrooms I had known. He quite reasonably eschewed an academic gown. More importantly, he ignored the seemingly indispensable projection in art history classes of lantern slides, then usually large and black-and-white, which were accompanied by post-lecture study of black-and-white photographic prints, whether mounted or not, on cardboard or illustrating books and periodicals.[5] Professor Sachs (and Professor Edward Forbes) had built a department which taught as much as possible with original works of art.

Most of the Museum Course classes were held in the Naumburg Room. Its rich interior and furnishings had been moved from the Manhattan apartment of Aaron and Nettie G. Naumburg on West 67th Street. After Mrs. Naumburg's death, it was reconstituted for academic and social uses in the new wing of the Fogg that the couple had endowed.[6] It was to seem to me that this sumptuous room, formed from a selection of the Naumburgs' possessions, represented the background that Professor Sachs had forsaken to concentrate on the teaching of fine arts at Harvard.

The Naumburg Room had a small troubadour staircase from which Professor Sachs would occasionally descend with great dignity. At the bottom of the stairs was an imposing desk which made him—a small, meticulously dressed man—even more formidable than he normally surprisingly appeared. I will never forget the day he came down those stairs, white with anger at our class. Although I have genuinely repressed the reason for his uncharacteristic ire, I do recall that I managed to face him first among the students, my back rigid with self-righteous indignation.

The Museum Course I entered in 1944 took half our academic time. In our year, because of the war, there were only four of us.[7] As I vividly recall, it was during our first meeting

that we found before us on a corner of Professor Sachs's desk in the Naumburg Room—but facing us—a small painting of the shadowed head of a somewhat melancholy young man (fig. 37). We knew so little about Degas that I did not even recognize his face. Professor Sachs asked us to guess the name of the artist. One of us tentatively suggested Courbet, which did have some logic, which he courteously acknowledged, saving us from total humiliation. In unmasking it as Degas, Professor Sachs was—quite unwittingly—enticing me onto the pilgrimage of a lifetime. He explained that the work was not his or even the Fogg's, but belonged to a French collector and dealer, Marcel Guérin, who had left it with him for the "Duration."[8]

In the painting on the desk, Degas's face is cast in the shadow of his soft hat, but his dark eyes and petulant lips emerge expressively, deeply melancholy and a little arrogant. The painting also reveals how much Degas had savored both color and paint. The presence of this painting before us proved typical of Professor Sachs—his desire to provide us at our first meeting with an object that was accessible, even on the market. Presumably it would puzzle us about its significance in the artist's career and even in the history of painting. I was bewildered then by Degas both as an artist and as a man. This painting turned out to be one of many self-portraits he had made in his thirties, probably when he was living on his own in Italy, having left the École des Beaux-Arts in Paris after an aborted attempt to study there. Professor Sachs made us see it as an object, somewhat influenced by the example of Courbet but more significant as an early effort by a master to find his own way.

The four of us in the class had come to the Fogg from different places and different institutions—and with different ambitions. But one thing we shared was that our different preparations in those different institutions had all, like mine, invariably been based upon black-and-white photographs, even in the periodicals or books we were reading. That small painting by Degas on Professor Sachs's desk was almost a challenge, an invitation to leave those indifferent black-and-white images behind us and to confront the reality of the actual work of art with its scale, its color, its texture, even its weight.

All four of us had already experienced something of the satisfaction of physical contact with a work of art. For me it had been surprisingly but most memorably with Sung porcelain from the Sir Percival David Collection, which was stored at Toronto's Royal Ontario Museum during the war. I had been permitted under the guidance of the curator, Bishop White, to lift and to stroke some of the Sung vases.[9] Whatever those experiences had been for each of us, we were still challenged by the small Degas on Professor Sachs's desk. Although we were not allowed to touch it, he was to tantalize us often with such temptations—and very often with a work by this artist.

It is unlikely that I can recall all the works by Degas that Professor Sachs brought for us to see. Most, of course, were his own, which were largely kept in his famous house, Shady Hill, a handsome Federal residence on large grounds within Cambridge. The house had been owned by the family of Charles Eliot Norton, who had been born there in 1827, was made Harvard's first professor of fine arts in 1875, and died at Shady Hill in 1908. His home was then bought by Edward Forbes, who soon sold it to Louise and Walter Arensberg, before this couple, inspired by the 1913 Armory Show of modern art, had adventurously acquired the works of Marcel Duchamp and his friends, which they were to give to the Philadelphia Museum of Art. They, in turn, shortly sold Shady Hill to Professor Sachs, completing the home's illustrious pedigree in the arts.[10]

There was one memorable occasion during the war when I was invited to Shady Hill for a black-tie dinner and found myself greeted by a properly attired manservant holding out to me a martini in a paper cup. When we went into the dining room, lined, as always, by a changing exhibition of drawings from the Sachs collection, we saw that the magnificent surface of the table was decorated with handsome silver and flowers, but that the wine and food were to be served in or on paper cups and paper plates. Mrs. Sachs explained that they could not ask the servants to wash the dishes in wartime. But the Sachses continued to entertain.

We were only invited to Shady Hill on a few occasions. More customarily Professor Sachs brought drawings from his collection to the Fogg for us to examine. Since in writing this I am depending upon my memory rather than notes, I am by no means certain of the order in which I saw his drawings by Degas. One thing that is certain is that those he brought were not dominated by studies of ballerinas, although he did take great pleasure in those he possessed. In retrospect—even now, sixty years later—I rather suspect he chose among his drawings those that were either sparer or more robust and therefore more difficult to understand.

One such drawing was the pencil study (with traces of white chalk) of a young woman who has been identified as Mme Julie Burtey (fig. 38), a study for a painting now in the Virginia Museum of Fine Arts (L. 108). Professor Sachs pointed out that the anxieties of this young woman were exposed, not so much in her dignified posture or in her some-what pinched features, as in her hand, anxiously fingering her shawl. He seemed to be able to project himself into Degas's figures whatever their circumstances, like a dancer mimicking their poses, which he consequently better understood.

Fig. 38
STUDY FOR "JULIE BURTEY,"
c. 1867
(no. 39)

The young woman in this drawing was proud but diffident. Another young woman in a drawing Professor Sachs owned, which Degas had made a few years later using a brush

and ink and gouache, is of an elaborately bustled figure whom we seem to catch by accident as she walks along the street and turns her head, which is crowned by a hat as fantastic as her bustle (fig. 39). It is as if she had suddenly and somewhat proudly become aware of us. Again, Professor Sachs emphasized how every movement in her body—in particular that proud lift to her head, along with the position Degas had given her just left of center on the page—was a highly evocative simplification.

In wartime we were not able to visit either Paris or Italy where Degas had worked, but by this time, over a quarter of a century after his death in 1917, his works were known and prized, spread over museums and private collections, many of them not far from the Fogg Museum. Professor Sachs made us feel how indispensable it was to visit and, with our eyes, absorb the originals. If it should be permitted, it was an even greater privilege to hold such a drawing in our hands.

As I have suggested, Professor Sachs seemed able to project himself into the bodies of the people Degas painted or drew, even when they were as conspicuously different from his own as those of Mme Burtey and the young woman with a bustle. He did, however, own two strong drawings of a Florentine critic, Diego Martelli, whose body, although grosser, somewhat resembled his own (figs. 15, 40). The vigorous charcoal and chalk drawings of Martelli were studies for the lively, asymmetrical painting that Degas exhibited in the fourth Impressionist exhibition in 1879 and that has been since 1932 in the National Gallery of Scotland in Edinburgh (L. 519). Although Professor Sachs only had the drawings showing Martelli's arms crossed in front of his generous waistcoated torso, he also knew the great painting in Edinburgh and the other drawings for it. In talking about the studies of Martelli, Professor Sachs inevitably seemed to free his chair from the confines of a desk to cross his ankles to balance his body—just as Martelli had done for Degas.

When Degas exhibited the portrait of Diego Martelli in the 1879 Impressionist exhibition in Paris, he also showed another portrait, of another male friend, the French writer and critic Edmond Duranty (L. 517). One study for this painting presents a seemingly insurmountable problem. It seems that the image of this work in the Fogg's collection is not the original drawing but a reproduction that was triumphantly successful and, as such, a warning to us (fig. 30). The original is—and was then—in the Metropolitan Museum of Art. Professor Sachs claimed to have been fooled by this facsimile—obviously a vivid admonition to us to be very careful not to follow his sorry example. My acceptance of this instructive story at face value then is evidence of my naïveté. It was only in writing this essay that I became skeptical of Professor Sachs's ever having been fooled by even the most brilliant facsimile reproduction. I mentioned this to Mrs. Cohn, who looked up the "drawing" of Duranty in the Fogg's files and discovered that the original owner of the

Fig. 39
YOUNG WOMAN IN STREET COSTUME, c. 1879
(no. 45)

reproduction had been another great collector and donor to the Fogg, Grenville Winthrop, whose collection (and also his butler, to act as a doorman) arrived at Harvard when I was a student. Although Mr. Winthrop was as unlikely to have been fooled as Professor Sachs himself, my faith in Professor Sachs was restored.

It may have been the result of the inevitable confinement imposed by World War II that I do not think of Professor Sachs as having been very curious about hunting down people who had known Degas. But there had been one exception of which he was very proud. Apparently he had been curious about Degas's paintings of a teacher of piano, Marie Dihau, and her brother, Désiré, the bassoonist in the Paris Opéra orchestra, which at that time were still in the possession of Mlle Dihau in the Paris apartment where Degas had visited and painted them. Professor Sachs seems to have secured the necessary letter of introduction to Mlle Dihau. He enjoyed describing himself climbing the many stairs leading to the Dihau apartment, where he was met by the charming piano teacher, who took great pride in showing the two paintings Degas had given the Dihaus—one with her brother blowing his bassoon against the background of the Paris orchestra (L. 186), the other of herself (fig. 25), considerably younger than she would have been when Professor Sachs met her, seated at the piano still in that Paris apartment. Mlle Dihau further enchanted Professor Sachs by telling him of their friend and distant cousin Henri de Toulouse-Lautrec, who had admired the older Degas more than Degas admired him. Lautrec would bring bands of drunken friends to see the two paintings in the Dihau apartment and order them: "Kneel down, you fools. Kneel down. Before the greatest artist of them all."

Fig. 40
STUDY FOR "DIEGO MARTELLI," 1879
(no. 41)

Fig. 41
Henri de Toulouse-Lautrec,
LES VIEILLES HISTOIRES (OLD TALES), 1893.
Lithograph, 45.7 x 60.5 cm (sheet). Fogg Art Museum, Harvard University Art Museums, Gift of Philip Hofer, M3611.

Professor Sachs may not have realized that the brother had had Professor Sachs's own proportions and those of Diego Martelli. But I have—framed on my bedroom wall—a sheet of music printed with a lithograph by Toulouse-Lautrec, with Désiré Dihau leading a bear on a leash beside the Seine (see fig. 41). It evokes for me the lovable, indomitable silhouettes of both Martelli and, above all, Professor Sachs.

Professor Sachs encouraged us to find the work of Degas where we could. He gave us one (rather frustrating) project, which was to write a paper on a recent gaudy reinstallation

of the Rhode Island School of Design Museum in nearby Providence. I was to discover (but perhaps not on this occasion) that there was a Pandora's box in its basement—a primitive dark storage, in which pastels were carefully protected from the light. There we found some ravishing pastels by Degas. The dancers were undoubtedly the most seductive, but the most surprising was a large sheet of studies of friends of Degas that the artist had encountered one summer while visiting his friends the Halévys at their cottage at Dieppe (fig. 42). The vertical panel represents a group of "artists"—exceedingly formal in dress and bearing—on the beach. At the left, isolated and alone, stands the handsome English painter Walter Sickert, with his back to the others. The rest—four men and a

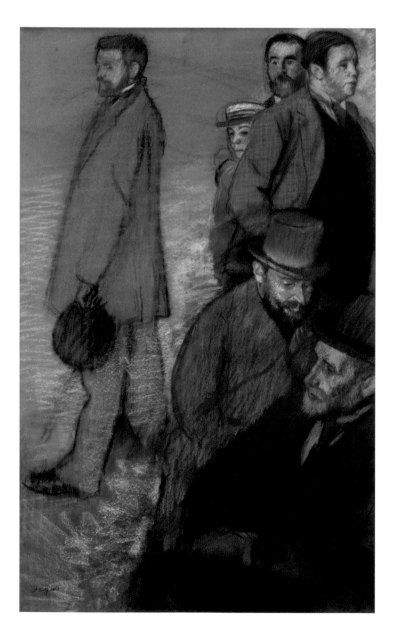

boy—are arranged in a vertical, like a totem, at the right. Descending, they are the writer and librettist Ludovic Halévy, a great friend of Degas from childhood; his young son Daniel, who would himself write about My Friend Degas; the massive figure of the French painter Jacques-Emile Blanche, apparently seated; the seemingly diabolical head and shoulders of another academic painter, Henri Gervex; and finally, sitting at the bottom, that close friend of Degas and the Halévys, Albert Cavé, to whom Degas referred as "that man of taste." This is in many ways an enigmatic work, with tantalizing references to Degas's life and career.

Other museums in the neighborhood not only had works by Degas but works that could raise important questions about his career. The Smith College Museum of Art, not far away in Northampton, Massachusetts, has two pivotal early paintings: one the portrait of the artist's younger brother René at the age of ten, the other from an Old Testament fantasy, an enormous romantic canvas The Daughter of Jephthah, which Degas submitted to the Salon of 1865 (fig. 13).

In moving across the river from Cambridge into Boston, we found more works by Degas. There is only one painting (but some drawings) in the Isabella Stewart Gardner Museum—the painting an Ingresque portrait of a ballet dancer, Mlle Gaujelin, in conventional black dress (L. 165). The Museum of Fine Arts

has much more, the result of a passion for the work of Degas on the part of many Bostonians, even before Professor Sachs moved from New York to Cambridge. In the "MFA," there is the magnificent double portrait of Degas's sister Thérèse with her husband, who was their Neapolitan first cousin, Edmondo Morbilli (L. 164). There are two of the painter's most beautiful small racetrack scenes, one of his friends the Valpinçons with their infant son in a carriage at the races in Normandy, which Professor Sachs had hoped to be able to buy for the Fogg (fig. 43), the other simply a gathering of horses and riders, presumably at a Parisian track (L. 334). There were other works, to which a major addition has been made recently—long after the demise of Professor Sachs: of the painter's aunt, the Duchess of Montejasi-Cicerale, and her two daughters, a purchase of which Professor Sachs would certainly have approved (L. 637). This added more Neapolitan relatives of Degas to that museum's collection. The Boston museum also has significant drawings and prints by Degas, and all of this makes Boston and Cambridge almost hallowed land in which to study the work of the artist. And in many ways, when I was there, Professor Sachs was the painter's prophet.

To move back across the river, Professor Sachs had apparently somewhat casually (and perhaps imprecisely) introduced another aspect of the work of Degas to the Fogg's collection—and that was photography. I can still recall that when I was a student at the Fogg I noticed rather foreign works in the corner of the Print Room, over which Dr. Jakob Rosenberg presided (figs. 26, 44). They turned out to be two large photographs

Fig. 42
SIX FRIENDS, 1886.
Pastel and chalk, 114.9 x 71 cm. Rhode Island School of Design Museum of Art, Museum Appropriation Fund. (L. 824)

Fig. 43
AT THE RACES IN THE COUNTRYSIDE, 1869.
Oil on canvas, 36.5 x 55.9 cm. Museum of Fine Arts, Boston, 1931 Purchase Fund. (L. 281)

of landscapes, which both mystified and attracted me. I was told that they were the work of Edgar Degas, an aspect of his work still to be explored. Long after, a curator at the Metropolitan Museum of Art, Malcolm Daniel, in an exhibition of Degas's little known photographs, revealed that aspect of his art, which Professor Sachs had discovered but had not investigated.[11] Malcolm Daniel somewhat doubted the customary dating of these two Fogg photographs and perhaps—although never brutally—their attribution to Degas. Even if he had not been exactly correct in the attribution, Professor Sachs, years before that pioneering study of Degas as a photographer, had sensed that this was a medium with which the artist would have wanted to experiment.

In fact, not too surprisingly, the Fogg Museum had other works—more certainly given to Degas—to satisfy or provoke our curiosity. There is, for example, an early painting of Spartan girls taunting Spartan youths (fig. 45), which would direct some of us eventually,

when the war was over, to study the final version in the National Gallery, London, where it had been transferred from the Courtauld Collection (L. 70). Both works suggest the fascination with adolescence that would lead Degas much later to make the figure to be cast in bronze of the *Little Dancer, Aged Fourteen* (fig. 23). In the Fogg, there is also the Coburn gift of the start of a race at Epsom (fig. 19), which would lead to the charms of his paintings of racetracks to be found at the Museum of Fine Arts in Boston. More puzzling is an oil sketch of three top-hatted men gathered around a table of cotton, given by Herbert N. Straus and created by the artist as an alternative to the great painting *A Cotton Office: New Orleans* (L. 320), now the glory of the Musée de Beaux Arts, Pau, in France.[12] Over time I have found that table of cotton as ominous as a tomb (fig. 17). Each of these Fogg works is associated with another in Degas's career that is recognized as a masterpiece. Each in its own way is particularly provocative in its relationship to the more complex or finished work. What could be more appropriate for a university collection?

Fig. 44
UNTITLED (THE HOURDEL ROAD, NEAR SAINT-VALÉRY-SUR-SOMME), 1895
(no. 70)

Fig. 45
STUDY FOR "YOUNG SPARTANS EXERCISING,"
c. 1860
(no. 3)

More self-possessed is the small painting at the Fogg of Mme Olivier Villette, sitting in the shadows in front of a window (fig. 18), but even that has associations beyond itself because it was once the possession of Mlle Marie Dihau, whose apartment Professor Sachs had so much enjoyed visiting.

Upon occasion the Fogg would have a Degas on loan. During the war it was the somewhat mysterious painting of Mme Jeantaud (L. 371), whose husband had been in the trenches with Degas during the Franco-Prussian War. I was impressed as she appeared mysteriously and continued to mystify us. Just as mysteriously Mme Jeantaud would disappear.

Professor Sachs did direct our paths in different ways where we might confront the work of this complex painter. These paths inevitably led us beyond Boston to New York. I remember on one of those occasions—when I seem to have escaped Degas—finding myself between Professors Sachs and Rosenberg at an auction sale of Rembrandt etchings at Parke-Bernet. I was certainly introduced by Professor Rosenberg and Professor Sachs into the hallowed, urbane galleries of the New York branch of Wildenstein, the international dealers. I am fairly certain it was there that I first saw the large horizontal and asymmetrical painting of Hortense, the daughter of Degas's friends the Valpinçons, leaning over a chest of drawers with an apple in her hand (L. 206). The Minneapolis Institute of Arts would be astute enough to buy it in 1948, perhaps because its young director, Richard S. Davis, had been a student at the Fogg.

Professor Sachs led us to other works by Degas beyond New York. Because of the war he was not able to take us to the Philadelphia collection of Henry McIlhenny, who at that time was with the Monuments Commission in Europe. As a result we did not see then at his house the great work by Degas, *Le Viol* (also known as *Interior*), which Mr. McIlhenny had first seen as an undergraduate at Harvard and bought after he graduated (fig. 1). It had been in the 1911 Fogg Degas exhibition, the single one-man exhibition of his work arranged in the artist's lifetime—anywhere—that did not have a commercial purpose.

In Washington, D.C., John Thacher was abroad with the Monuments Commission and therefore could not show us the drawings by Degas in his Washington flat, as he would normally do for students in Harvard's Museum Course. But we did stay in Dumbarton Oaks, the great house of Mr. and Mrs. Robert Woods Bliss, innocently unaware that the house, the beautiful grounds, the works of art, and the endowment had already been given to Harvard in response to the encouragement of our Professor Sachs. My memory is vague enough that I cannot be sure I did see the two great works by Degas in the Bliss collection then: a drawing of an impudent Giulia Bellelli, a Florentine cousin of the artist, twisted on a chair; and the scene of a duet in a New Orleans drawing room, the

Fig. 46
THE SONG REHEARSAL,
1872–73
(no. 9)

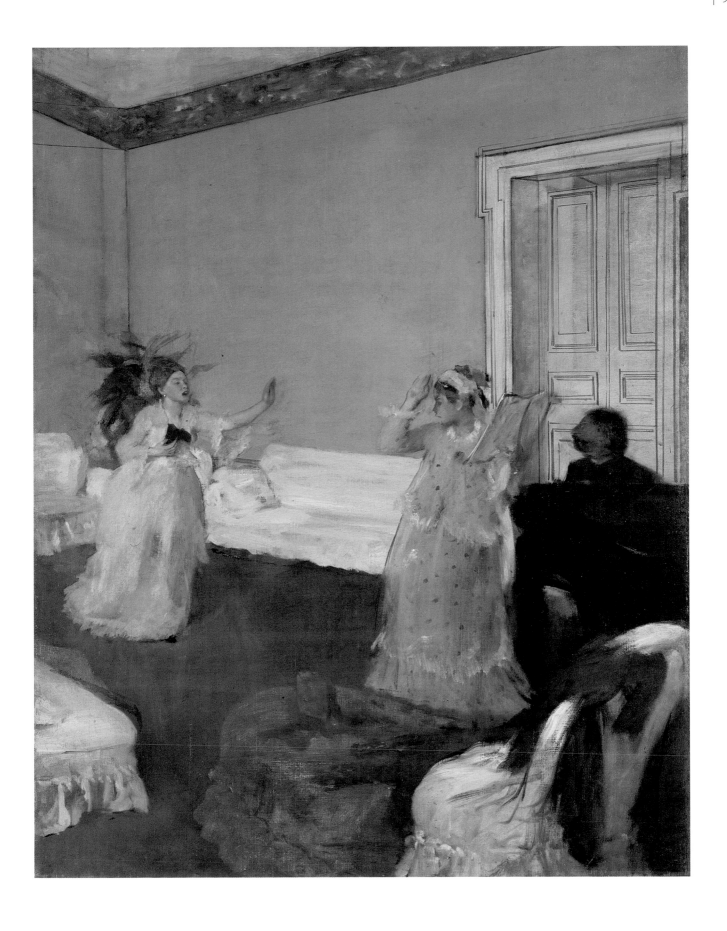

monochromatic dresses of the two singers glimmering against the pink wall and the green of the leaves of large potted plants (figs. 29, 46). This painting gives us some sense of the background of the painter's New Orleans-born mother.

I am certain I can recall Professor Sachs in an unfinished part of the very new building of the National Gallery of Art in Washington, which was about to exhibit works by Degas given by Joseph E. Widener. He was looking at the skylights, some still not installed and lying on the floor, and marveling at their height. I can still vividly recall his saying that the skylights were sixty feet above the top of the walls, which guaranteed a highly refined filtering of the light through the glass. As I watched him I could detect no envy, even if the Fogg was so modest by comparison, but instead he showed his very real pride in this great national institution, which Andrew Mellon had given to the United States of America. On its walls great works by Degas would be intelligently and sensitively exhibited.

I did see Professor Sachs after this Washington visit, but very soon both my term in the Museum Course and the end of the Second World War essentially brought our dialogue about Degas to an end. The next year Professor Frederick Deknatel, my advisor, did give a course on Degas, which I did not take but attended sporadically, enough to know that the poet Richard Wilbur was in the class. Yet on the whole my place in the sphere of Professor Sachs was quickly replaced by a flood of students. Many were veterans returning to the place they had been when the war had intervened; others were coming adventurously for the first time.

I finished my course work for a Ph.D. and was given one of the fellowships Professor Sachs's brother Arthur had endowed for travel and study in Europe. When I returned to the Fogg briefly, I remember Agnes Mongan, who had essentially become Sachs's collaborator on Degas, showing me the catalogue of the artist's paintings, which had just been published in Paris by Paul-André Lemoisne of the Bibliothèque Nationale.[13] By then I had decided—I hope with the approval of Professor Sachs—to work on Degas.

A POSTSCRIPT

Over the years since, the facts of this reticent painter's life have been somewhat grudgingly uncovered. They were finally superbly brought together and carefully assessed by an old Degas friend of mine who is now the director of the Louvre, Henri Loyrette, in his fat, remarkably documented book, which was published in 1991.[14] Since then Harvey Buchanan, retired as a dean and professor of the history of art at Case Western Reserve University in Cleveland, has discovered new evidence regarding Degas's religious back-

ground: he was baptized a Protestant, although he was given Roman Catholic last rites at his death, at the behest of his maidservant.[15]

Professor Sachs would have been pleased to know that work has continued on Degas's life and art, which had so much enlivened his own career. He would have taken particular pride in the work of one Harvard graduate, Eugenia Parry (Janis), on the monotypes and of another, Theodore Reff, on Degas's notebooks.[16] And there will be others, possibly unknown to us now, who will be seeking, perhaps not at Harvard but as Professor Sachs would have wished, to find the truth about the life and work of Edgar Degas.

I was never to devote all of my life to Degas. After writing a dissertation on his family portraits, I did publish an article in the *Art Bulletin* on his painting of the Bellelli family, and I made an attempt in three articles in the *Burlington* to put his notebooks at the Bibliothèque Nationale in some kind of order,[17] an effort soon surpassed by the work of that other Fogg student and distinguished Degas scholar, Theodore Reff.

In 1967 an exhibition I organized of Degas drawings for the Saint Louis Art Museum was shown at the Philadelphia Museum of Art and the Minneapolis Institute of Arts, all of

Fig. 47
AFTER THE BATH (WOMAN DRYING HERSELF), 1896.
Oil on canvas, 89 x 116 cm.
Philadelphia Museum of Art, Purchased with Funds from the Estate of George D. Widener.
(L. 1231)

which had as directors Fogg Museum Course graduates who were approximately my contemporaries.[18] I have been told that this persuaded another Fogg graduate and distinguished collector, Joseph Pulitzer, to start buying drawings by Degas. It was many years before I worked with three other colleagues equally obsessed with Degas—Henri Loyrette, Gary Tinterow of the Metropolitan Museum of Art (another Fogg graduate), and Michael Pantazzi of the National Gallery of Canada—to produce a retrospective exhibition of the work of Degas that was shown in Ottawa (the first exhibition at the new National Gallery of Canada building), in New York at the Metropolitan, and in Paris at the Grand Palais.[19]

Finally, I had something to do with the acquisition of the large, late reddish painting of a nude (fig. 47), which Degas had based upon a photograph and which was bought for the Philadelphia Museum of Art when I was briefly its director. When the museum did not have the ready money to make the acquisition, one of its trustees stepped in and paid for it. His name was Fitz Dixon, and his mother was a Widener.

Professor Sachs would have been proud that certain Harvard connections with Degas have survived.

NOTES

1 The course is described in the *Harvard University Catalogue* (Cambridge, September 1944), 183: "Primarily for graduates: 19Aa and 19Ab. Seminar in Museum Work and Museum Problems. (2) Professor Sachs and Associate Professor Rosenberg."

2 *Artist in His Studio* (sometimes titled *Portrait of Henri Michel-Levy*), c. 1878; bought in 1891 from Boussod, Valladon & Cie, Paris, by Sir George A. Drummond, Montreal; sold by his heirs at Christie's, London, 1919 (L. 326).

3 *Mlle La La at the Cirque Fernando*, 1879; sold in 1905 by Durand-Ruel to Cawthra Mulock (son of Sir William Mulock), Toronto, who died in 1918. The provenance is uncertain from 1918 until its sale in 1925 by the French Gallery, London, to the Courtauld Fund, London (L. 522).

4 It is impossible for me now to be certain of the sources for these two reproductions, although I believe they were related to the large oil painting on canvas (L. 1267) that was transferred from the collection of Chester Dale to the National Gallery, Washington. Pastels in the Museum of Modern Art in Moscow (L. 1274) and the Toledo (Ohio) Museum (L. 1344) are possible sources for one of the reproductions.

5 Admittedly, although Professor Sachs and his colleague in much of this activity, Edward Forbes, were determined that study at the Fogg should be dominated by original works of art, the record shows that the two men supported the acquisition of photographic archives for scholarly study, but never for classes when they could be avoided. See the essay by Marjorie Cohn in this catalogue for the attempt by Professor Sachs to acquire an archive of Degas photographs for teaching purposes.

6 The Naumburg Room, which occupies the second floor of the Naumburg Wing of the Fogg Art Museum, was opened in 1932. See *Bulletin of the Fogg Art Museum* 2, no. 1 (1932): 18.

7 The other three members of the class were: Mary De Wolfe, who was somewhat older and had a varied career including working as an interior decorator and as an assistant to Richard S. Davis, later director of the Minneapolis Institute of Arts but then curator and director at Cranbrook Academy of Art. While De Wolfe was a student in the Museum Course she worked part-time for Gertrude Townsend, the curator of textiles at the Museum of Fine Arts in Boston. She ended as the head of the most handsome and meticulous slide room I have ever seen, at the University of California at Los Angeles. Another member of the class was Bennet Freeman from Winnetka, Illinois, who had studied at Northwestern University and had become seduced by drawings at the Print Room of the Art Institute of Chicago, to which she remained attached at the time of her untimely death. The only male member of the class was John Maxon, who had studied engineering at Cooper Union but had switched to art history by the time he arrived at Harvard. He would direct the museum at the University of Kansas at Lawrence and, more famously, the Art Institute of Chicago. Perhaps for the record I should add that I was to direct the National Gallery of Canada for ten years (1966–76) and the Philadelphia Museum of Art for three (1979–82).

8 See the essay by Mrs. Cohn in this catalogue for more information about Guérin, his interest in Degas, and his friendship with Paul Sachs. What she does not mention is that Guérin was also a picture dealer.

9 On this collection, see R. L. Hobson, *A Catalogue of Chinese Pottery and Porcelain in the Collection of Sir Percival David, bt., F.S.* (London, 1934). The Rt. Rev. William Charles White was Anglican bishop of Hunan, China, for forty years and then director of the School of Chinese Studies at the University of Toronto and keeper of Far Eastern art, and assistant director of the Royal Ontario Museum, Toronto.

10 Harvard purchased Shady Hill from Professor Sachs in 1954 and, unable to find another tenant, razed the house in 1955. After protracted consideration about the possible use of the large property for graduate student housing, the land was leased to the American Academy of Arts and Sciences, which has built its modern headquarters there. For a brief history of the house, see *Harvard Alumni Bulletin* 57, no. 3 (1954): 106–8.

11 Malcolm Daniel, *Edgar Degas, Photographer*, exh. cat., Metropolitan Museum of Art (New York, 1998). The catalogue contains essays by Eugenia Parry and Theodore Reff, two Degas scholars trained at Harvard University.

12 Jean Sutherland Boggs, *Degas*, exh. cat., Galeries Nationales du Grand Palais, National Gallery of Canada, Metropolitan Museum of Art (New York and Ottawa, 1988), 188.

13 Paul-André Lemoisne, *Degas et son oeuvre*, 4 vols., 1946–49 (Paris, c. 1946).

14 Henri Loyrette, *Degas* (Paris, 1991).

15 For Degas's birth certificate see Jean Sutherland Boggs, "New Orleans and the Work of Degas," in *Degas and New Orleans: A French Impressionist in America*, exh. cat., New Orleans Museum of Art (New Orleans, 1999), 104, n. 4.

16 Eugenia Parry Janis, *Degas Monotypes: Essay, Catalogue, and Checklist*, exh. cat., Fogg Art Museum (Cambridge, Mass., 1968); Theodore Reff, *The Notebooks of Edgar Degas: A Catalogue of the Thirty-Eight Notebooks in the Bibliothèque Nationale and Other Collections* (Oxford, 1976).

17 Jean Sutherland Boggs, "Edgar Degas and the Bellellis," *Art Bulletin* 37, no. 2 (1955): 127–36; Boggs, "Degas Notebooks at the Bibliothèque Nationale," *Burlington Magazine* 100, nos. 662, 663, 664 (1958): 163–71, 196–205, 240–46.

18 Jean Sutherland Boggs, *Drawings by Degas*, exh. cat., City Art Museum of Saint Louis, Philadelphia Museum of Art, Minneapolis Society of Fine Arts (St. Louis, 1966). The directors were Charles E. Buckley, Evan H. Turner, and Anthony M. Clark, respectively.

19 Boggs, *Degas*.

CHECKLIST & PROVENANCE

EDWARD SAYWELL AND STEPHAN WOLOHOJIAN

Dimensions are given in centimeters, height preceding width and followed by depth in the case of the sculptures. All works are in the collection of the Fogg Art Museum, unless otherwise noted. Works are organized by genre (paintings, sculpture, drawings, prints, photographs, and other original material) in the order of the year they came to the Harvard University Art Museums, followed by long-term loans.

KEY TO ABBREVIATIONS

Vente 1
Atelier Degas Vente 1, May 6–8, 1918, Galerie Georges Petit, Paris

Vente 2
Atelier Degas Vente 2, December 11–13, 1918, Galerie Georges Petit, Paris

Vente 3
Atelier Degas Vente 3, April 7–8, 1919, Galerie Georges Petit, Paris

Vente 4
Atelier Degas Vente 4, July 2–4, 1919, Galerie Georges Petit, Paris

Vente d'Estampes
Galerie Manzi-Joyant. *Catalogue des eaux-fortes, vernis-mous, aqua-tintes, lithographies et monotypes par EDGAR DEGAS et provenant de son atelier.* Paris, November 22–23, 1918.

Daniel
Daniel, Malcolm. *Edgar Degas, Photographer.* Exh. cat, The Metropolitan Museum of Art. New York, 1998.

Delteil
Delteil, Loys. *Edgar Degas, Le peintre graveur illustré,* vol. 9. Paris, 1919.

Janis
Janis, Eugenia Parry. *Degas Monotypes.* Exh. cat., Fogg Art Museum. Cambridge, Mass., 1968.

Reed and Shapiro
Reed, Sue Welsh and Barbara Stern Shapiro. *Edgar Degas: The Painter as Printmaker.* Exh. cat., Museum of Fine Arts, Boston, 1984.

LANDSCAPE (detail),
1890–92
(fig. 7, no. 65)

PAINTINGS

1

ALICE VILLETTE, 1872
Oil on canvas
46.4 x 33 cm
Gift of C. Chauncey Stillman,
Class of 1898, in memory of
his father, James Stillman
1925.7

Acquired from the artist by Marie
Dihau, Paris; Durand-Ruel, Paris,
1922; purchased from them by
C. Chauncey Stillman as a gift to
the Fogg Art Museum, 1925.
[Fig. 18]

2

**COTTON MERCHANTS IN
NEW ORLEANS,** 1873
Oil on canvas
58.7 x 71.8 cm
Gift of Herbert N. Straus
1929.90

Vente 1, no. 3; purchased at that
sale by Paul Rosenberg (Fr 17,500);
purchased from him by Herbert N.
Straus, through Wildenstein, New
York, 1929 ($8,500); his gift to the
Fogg Art Museum, 1929.
[Fig. 17]

3

**STUDY FOR "YOUNG
SPARTANS EXERCISING,"**
c. 1860
Oil on paper, mounted overall
on long-fibered paper, affixed
to cardboard
20.9 x 28 cm
Friends of the Fogg Museum,
Alpheus Hyatt, William M.
Prichard, and Francis H. Burr
Memorial Funds
1931.51

Vente 2, no. 45 (Fr 5,000); Durand-
Ruel, Paris; Chester H. Johnson
Galleries, Chicago; purchased from
them by Paul J. Sachs for the Fogg
Art Museum, March 12, 1931
($1,800).
[Fig. 45]

4

AT THE RACES: THE START,
c. 1860–62
Oil on canvas
33 x 47 cm
Bequest of Annie Swan Coburn
1934.30

Vente 1, no. 91 (Fr 34,300);
purchased at that sale by Leon
Orosdi, Paris; his sale, Hôtel
Drouot, Paris, May 25, 1923, no. 12
(Fr 21,000); purchased at that sale
by Étienne Bignou "pour Mr. Lefèvre
de Londres"; Ernest Lefevre,
London; Howard Young, New York;
purchased from him by Annie Swan
Coburn, Chicago; her bequest to the
Fogg Art Museum, 1934.
[Fig. 19]

5

BALLET DANCER,
c. 1873–1900
Oil on canvas
41.3 x 32.9 cm
Bequest of Grenville L.
Winthrop
1943.232

Percy Moore Turner, London;
Wildenstein, New York; purchased
from them by Grenville L. Winthrop,
New York, May 28, 1928 ($10,450);
his bequest to the Fogg Art
Museum, 1943.
[Fig. 21]

6

THE REHEARSAL, c. 1873–78
Oil on canvas
45.7 x 60 cm
Bequest from the Collection
of Maurice Wertheim, Class
of 1906
1951.47

Michel Manzi, Paris; Harris
Whittemore, Naugatuck, Conn., by
1911; Maurice Wertheim, New York,
1942; his bequest to the Fogg Art
Museum, 1951.
[Fig. 3]

7

SINGER WITH A GLOVE,
c. 1878
Pastel on canvas
52.9 x 41.1 cm
Bequest from the Collection
of Maurice Wertheim, Class
of 1906
1951.68

Camille Groult, Paris, by 1879; Fritz
Heer, Zurich; César Mange de
Hauke, New York, 1948; purchased
from him by Maurice Wertheim,
New York, April 1949; his bequest
to the Fogg Art Museum, 1951.
[Fig. 31]

8

**HORSES AND RIDERS ON
A ROAD,** 1867–68
Oil on cradled panel
47 x 59.8 cm
Promised gift of Janine and
J. Tomilson Hill
TL39628

Vente 1, no. 80 (Fr 7,500); purchased
at that sale by M. Gumaelius, Paris;
his sale, Galerie Georges Petit, Paris,
June 8, 1922, no. 7; purchased at
that sale by Ambroise Vollard, Paris;
Galerie Mouradian-Valloton, Paris,
by March 1938; Nathan Cummings,
New York, before 1965; his wife,
Joanne Toor Cummings; her estate
sale, Christie's, New York, April 30,
1996, no. 19; Janine and J. Tomilson
Hill, New York.
[Fig. 36]

9

THE SONG REHEARSAL,
1872–73
Oil on canvas
81 x 65 cm
Dumbarton Oaks Research
Library and Collection,
Washington, D.C.
HC.P.1918.02.(O)

Vente 1, no. 106 (Fr 100,000);
purchased at that sale by Walter
Gay for Mildred and Robert Woods
Bliss, Washington, D.C.; their gift
to Harvard University, for the
Dumbarton Oaks Research Library
and Collection, November 1940.
[Fig. 46]

Fig. 48, no. 13

10

GIULIA BELLELLI, STUDY FOR "THE BELLELLI FAMILY," 1858–59
Essence and graphite on thin buff wove paper mounted on panel
36.2 x 24.8 cm
Dumbarton Oaks Research Library and Collection, Washington, D.C.
HC.P.1937.12.(E)

Michel Manzi, Paris; his sale, Galerie Manzi-Joyant, Paris, March 13–14, 1919, no. 32 (Fr 15,000); purchased at that sale by Dikran Khan Kelekian, New York; his sale, American Art Association, New York, January 30–31, 1922, no. 101 (bought in through Durand-Ruel at $2,900); purchased from them by Mildred and Robert Woods Bliss, Washington, D.C., April 9, 1937; their gift to Harvard University, for the Dumbarton Oaks Research Library and Collection, November 1940.

[Fig. 29]

SCULPTURE

11

LITTLE DANCER, AGED FOURTEEN, modeled c. 1880
Bronze with tulle skirt and satin hair ribbon
99.1 x 35.6 x 35.6 cm
Inscriptions: Unnumbered/C; *Degas*; CIRE/PERDUE/A.A. HEBRARD
Bequest of Grenville L. Winthrop
1943.1128

A. A. Hébrard Foundry, Paris; purchased from them by Stephen C. Clark, New York, 1924; Scott & Fowles, New York; purchased from them by Grenville L. Winthrop, New York, December 1924 ($4,500); his bequest to the Fogg Art Museum, 1943.
[Fig. 23]

12

ARABESQUE OVER THE RIGHT LEG, LEFT ARM IN LINE, modeled c. 1880–85
Bronze
17 x 17 x 9.1 cm
Inscriptions: 3/B; *Degas*; CIRE/PERDUE/A.A. HEBRARD
Bequest of Grenville L. Winthrop
1943.1129

A. A Hébrard Foundry, Paris; sold to Durand-Ruel, New York, through Walter Halverson, Paris, 1922; on tour until the close of the exhibition at Ferargil Galleries, New York, November 9, 1925; Jacques Seligmann & Co., Inc., New York; purchased from them by Grenville L. Winthrop, New York, May 2, 1935; his bequest to the Fogg Art Museum, 1943.
[Fig. 49]

13

GRANDE ARABESQUE, THIRD TIME, modeled c. 1885–90
Bronze
40.2 x 55.4 cm
Inscriptions: 16/D; *Degas*; CIRE/PERDUE/A.A. HEBRARD
Bequest from the Collection of Maurice Wertheim, Class of 1906
1951.78

A. A. Hébrard Foundry, Paris; purchased from them by Walter Halverson, Paris; purchased from him by Justin K. Thannhauser, August 12, 1929–March 18, 1945; purchased from him by Maurice Wertheim, New York, April 1945; his bequest to the Fogg Art Museum, 1951.
[Fig. 48]

14

HORSE TROTTING, THE FEET NOT TOUCHING THE GROUND, modeled c. 1881–90
Bronze
22.9 x 27.2 cm
Inscriptions: 49/B; *Degas*; CIRE/PERDUE/A.A. HEBRARD
Bequest from the Collection of Maurice Wertheim, Class of 1906
1951.79

A. A. Hébrard Foundry, Paris; sold to Durand-Ruel, New York, through Walter Halverson, Paris, 1922; on tour until the close of the exhibition at Ferargil Galleries, New York, November 9, 1925; Mary Quinn Sullivan, after 1925; her sale, Anderson Galleries, New York, April 29–May 1, 1937, no. 221 ($70); purchased at that sale by John H. Seitz (?); Maurice Wertheim, New York, by 1944; his bequest to the Fogg Art Museum, 1951.
[Fig. 50]

15

WOMAN TAKEN UNAWARES, modeled c. 1890–1900
Bronze
40.6 x 29.6 x 19 cm
Inscriptions: 42/H; *Degas*; CIRE/PERDUE/A.A. HEBRARD
Gift of Mr. and Mrs. Edward M. M. Warburg
1960.680

A. A. Hébrard Foundry, Paris; Edward M. M. Warburg, New York; his gift to the Fogg Art Museum, 1960.
[Fig. 51]

16

THE MASSEUSE, modeled c. 1895–1900
43 x 36.5 x 42.5 cm
Bronze
Inscriptions: 55/O; *Degas*; CIRE/PERDUE/A.A. HEBRARD
Lent by Mrs. Arthur K. Solomon, promised gift to the Fogg Art Museum
TL39532.2

A. A. Hébrard Foundry, Paris; Richard Davis, Minneapolis; acquired from him by Julius Weitzner, New York, 1957 (?); purchased from him by Arthur K. Solomon, Cambridge, Mass., 1957 (?); promised gift to the Fogg Art Museum.
[Fig. 28]

Fig. 49, no. 12

Fig. 50, no. 14

Fig. 51, no. 15

Fig. 52, no. 17

Long-Term Loan

17

DANCER RUBBING HER KNEE,
modeled c. 1880–85
Bronze
31 x 14.2 x 24.2 cm
Inscriptions: 39/K; *Degas;*
CIRE/PERDUE/A.A. HEBRARD
Loan from the Collection
of Edouard Sandoz
45.1965

Edouard Sandoz, Paris; by descent.
[Fig. 52]

DRAWINGS

18

**AFTER THE BATH, WOMAN
WITH A TOWEL,** c. 1893–97
Pastel on blue-gray wove paper
70.8 x 57.3 cm
Gift of Mrs. J. Montgomery
Sears
1927.23

Adolphe Tavernier, Paris; his sale,
Galerie Georges Petit, Paris, March
6, 1900, no. 114 (Fr 6,800); Mrs. J.
Montgomery Sears, Boston; her gift
to the Fogg Art Museum, 1927.
[Fig. 4]

19

**A NUDE YOUTH CRAWLING,
STUDY FOR "YOUNG
SPARTANS EXERCISING,"**
c. 1860
Oil on paper-covered board
24 x 31.7 cm
Gift of Mrs. Albert D. Lasker
1927.62

Vente 1, no. 62b; purchased at
that sale by Jos Hessel; Mrs. Mary
Woodard Reinhardt (later Mrs.
Albert D. Lasker), New York; her
gift to the Fogg Art Museum, 1927.
[Fig. 54]

20

**LORENZO DE' MEDICI AND
ATTENDANTS, AFTER "THE
PROCESSION OF THE MAGI,"
BY BENOZZO GOZZOLI,** 1860
Graphite on off-white wove
paper
25.9 x 30.4 cm
Gift of Henry S. Bowers,
Class of 1900
1929.259

Vente 4, part of no. 91; Vaudoyer (?);
César Mange de Hauke, Paris; Hôtel
Drouot, Paris, November 12–13,
1928, no. 368; purchased at that sale
by Henry S. Bowers, New York; his
gift to the Fogg Art Museum, 1929.
[Fig. 57]

21

**THREE PAGES, AFTER "THE
PROCESSION OF THE MAGI,"
BY BENOZZO GOZZOLI,** 1860
Graphite and prepared black
chalk on thin off-white wove
paper
41.6 x 20.2 cm
Gift of Henry S. Bowers,
Class of 1900
1929.260

Vente 4, part of no. 91; Vaudoyer (?);
César Mange de Hauke, Paris; Hôtel
Drouot, Paris, November 12–13,
1928, no. 368; purchased at that sale
by Henry S. Bowers, New York; his
gift to the Fogg Art Museum, 1929.
[Fig. 55]

22

**STUDY FOR "JAMES-JACQUES-
JOSEPH TISSOT,"** c. 1867–68
Prepared black chalk on two
pieces of tan wove paper
32.8 x 41.2 cm
Gift of César M. de Hauke
1930.17

Vente 3, no. 158.1 (Fr 1,500);
purchased at that sale by Henri
Fiquet, Paris; César Mange de
Hauke, New York; his gift to the
Fogg Art Museum, 1930.
[Fig. 69]

23

MOUNTED JOCKEY, c. 1866
Essence, black ink, and
gouache on tan wove paper
26.7 x 13.1 cm
Meta and Paul J. Sachs
Collection, Fogg Art Museum
341.1936 [stolen]

Vente 3, no. 114c (framed with two
other drawings; Fr 3,355 for the lot
of three); Scott & Fowles, New York;
purchased from them by Paul J.
Sachs, Cambridge, Mass., by 1927;
Meta and Paul J. Sachs Collection,
Fogg Art Museum, by 1936; stolen
while on exhibition at the Virginia
Museum of Fine Arts, Richmond,
1952.
[Fig. 73]

24

**HALF-LENGTH STUDY OF
A WOMAN,** c. 1890
Charcoal and pastel on
blue-gray wove paper
57.5 x 50.8 cm
Gift of Arthur Sachs
1940.2

Vente 2, no. 126 (bought in); Paul
Rosenberg, Paris; Paul J. Sachs,
Cambridge, Mass., by 1929; Jacques
Seligmann & Co., Inc., New York,
January 1940; gift of Arthur Sachs
(by exchange) to the Fogg Art
Museum, 1940.
[Fig. 32]

Fig. 53, no. 53

Fig. 54, no. 19

25
**HEAD OF A BEARDED OLD
MAN, AFTER A DRAWING IN
THE LOUVRE BY FRANÇOIS
CLOUET,** c. 1855
Graphite and white gouache
on tan wove paper
30.4 x 23.5 cm
Gift of the Museum of Modern
Art, New York
1943.26

Vente 4, no. 87d (framed with three
other drawings; Fr 1,400 for the lot
of four); purchased at that sale by
Charles Vignier, Paris; Lillie P. Bliss,
New York, by 1922; her bequest to
the Museum of Modern Art, New
York, 1934; its gift to the Fogg Art
Museum, 1943.
[Fig. 63]

26
THREE MOUNTED JOCKEYS,
c. 1868–70
Graphite and black chalk on
tan wove paper
19.7 x 27.6 cm
Bequest of Grenville L.
Winthrop
1943.809

Vente 3, no. 354.2; René De Gas,
brother of the artist, Paris, 1919;
his sale, Hôtel Drouot, Paris,
November 10, 1927, no. 22b
(Fr 12,500); purchased at that sale
by Thomson (?) [possibly Lawson
Thompson, Hitchin, England];
acquired by Grenville L. Winthrop,
New York, through Martin Birn-
baum, July 2, 1928 (£115); his
bequest to the Fogg Art Museum,
1943.
[Fig. 71]

27
**HORSE WITH SADDLE AND
BRIDLE,** c. 1868–70
Black chalk on thin off-white
wove paper
22.8 x 31 cm
Bequest of Grenville L.
Winthrop
1943.810

Vente 4, no. 209a (framed with
another drawing; Fr 3,600 for the
lot of two); purchased at that sale
by Reginald Davis, Paris; Scott &
Fowles, New York; purchased from
them by Grenville L. Winthrop,
New York, July 13, 1923 ($500); his
bequest to the Fogg Art Museum,
1943.
[Fig. 22]

28
**MOURNERS, AFTER
"SACRAMENT OF EXTREME
UNCTION," BY NICOLAS
POUSSIN,** c. 1856
Prepared black chalk on
off-white modern laid paper
47.6 x 30.9 cm
Bequest of Grenville L.
Winthrop
1943.811

Vente 4, no. 95c (framed with two
other drawings; Fr 1,020 for the lot
of three); purchased at that sale by
LeGarrec, Paris; Scott & Fowles,
New York; purchased from them by
Grenville L. Winthrop, New York,
October 16, 1920 ($400); his
bequest to the Fogg Art Museum,
1943.
[Fig. 60]

29
**TWO DANCERS ENTERING
THE STAGE,** c. 1877–78
Pastel over monotype in black
ink on white modern laid paper,
discolored to tan
38.1 x 35 cm
Bequest of Grenville L.
Winthrop
1943.812

Possibly Ambroise Vollard, Paris;
Bernheim-Jeune, Paris, by 1918;
purchased from them by César
Mange de Hauke, Paris; purchased
from him by Major [Percy Moore?]
Turner, London; acquired from him
by Grenville L. Winthrop, New York,
through Martin Birnbaum, July 4,
1928 (£2,500); his bequest to the
Fogg Art Museum, 1943.
[Fig. 20]

30
MOUNTED JOCKEY, c. 1870
Graphite on off-white wove
paper (a copy of "Proclamation
de l'Empereur")
20.7 x 25.7 cm
Gift of César de Hauke
1947.20

César Mange de Hauke, New York;
his gift to the Fogg Art Museum,
1947.
[Fig. 72]

31
**PORTRAIT OF A WOMAN,
AFTER ANTHONY VAN DYCK,**
c. 1860
Prepared black chalk on thin
off-white wove paper
30.7 x 18.2 cm
Gift of Meta and Paul J. Sachs
1955.2

Mathias Komor, New York; pur-
chased from him by Meta and Paul J.
Sachs, Cambridge, Mass., December
1954 ($425); their gift to the Fogg Art
Museum, 1955.
[Fig. 62]

32
**STUDIES OF FIGURES, AFTER
"JUDGMENT OF PARIS"
AND "PARNASSUS," BY
MARCANTONIO RAIMONDI,**
c. 1853–56
Brown ink on cream tracing
paper
15.2 x 31.2 cm
Anonymous gift in memory
of W. G. Russell Allen
1956.10

By descent from the artist to Jeanne
Fevre, Nice; Henri Petiet, Paris;
anonymous gift to the Fogg Art
Museum, 1956.
[Fig. 61]

33
Attributed to Hilaire-Germain-
Edgar Degas
ITALIAN GIRL, c. 1856
Watercolor and graphite on off-
white wove paper, laid down
overall to off-white wove paper
15.5 x 13.6 cm
Gift of Mr. and Mrs. Joseph H.
Hazen
1959.155

Private collection, Paris; their sale,
Hôtel Drouot, Paris, June 27, 1949,
no. 6; Étienne Ader, Paris; Wilden-
stein, New York; Mr. and Mrs.
Joseph H. Hazen, New York; their
gift to the Fogg Art Museum, 1959.
[Fig. 65]

Fig. 56, no. 50

Fig. 55, no. 21

Fig. 57, no. 20

Fig. 58, no. 34 verso

Fig. 59, no. 35 verso

Fig. 60, no. 28

34
STUDIES FOR "THE DAUGHTER
OF JEPHTHAH" (recto and
verso), c. 1859–61
Graphite on wove oatmeal
paper; verso: graphite
32.2 x 24.7 cm
Bequest of Marian H. Phinney
1962.28

Vente 1, no. 6b; Le Bateau-Lavoir,
Paris, 1959 ($800); Marian Harris
Phinney, Cambridge, Mass.; her
bequest to the Fogg Art Museum,
1962.
[recto: Fig. 12; verso: Fig. 58]

35
STUDY OF A HORSE FROM THE
PARTHENON FRIEZE; verso:
THREE DRAPERY STUDIES
FROM THE PARTHENON
FRIEZE, c. 1854
Prepared black chalk on off-
white modern laid paper;
verso: prepared black chalk
35.1 x 32.1 cm
Gift of Mrs. Bernard Helman in
honor of Miss Agnes Mongan
1964.136

Atelier Degas, Paris; Le Bateau-
Lavoir, Paris; purchased from
them by Mrs. Bernard Helman,
Cambridge, Mass.; her gift to the
Fogg Art Museum, 1964.
[recto: Fig. 11; verso: Fig. 59]

36
RENÉ DE GAS, CONVALESCENT,
c. 1855
Graphite on off-white wove
paper
34.4 x 8.2 cm
Bequest of Meta and
Paul J. Sachs
1965.251

Gift of the artist to his brother, René
De Gas, Paris; by descent to his son
Edmond de Gas, Paris; purchased
from him by Léonce Mauger, Paris;
Jean Cailac, Paris; purchased from
him by Paul J. Sachs, Cambridge,
Mass., November 4, 1935 (Fr 400);
his bequest to the Fogg Art
Museum, 1965.
[Fig. 68]

37
A YOUNG WOMAN RECLINING
IN A CHAIR, c. 1868–70
Graphite on off-white modern
laid paper, laid down overall
and counterlined
23.6 x 48.3 cm
Bequest of Meta and
Paul J. Sachs
1965.252

Vente 4, no. 136c (framed with two
other drawings; Fr 1,850 for the lot of
three); Marcel Bing, Paris; Charles
Vignier, Paris; purchased from him
by Paul J. Sachs, Cambridge, Mass.,
by 1927; his bequest to the Fogg Art
Museum, 1965.
[Fig. 67]

38
STUDY FOR "WOMAN
SEATED BESIDE A VASE OF
FLOWERS (MADAME PAUL
VALPINÇON?)," 1865
Graphite on off-white wove
paper
35.5 x 23.3 cm
Bequest of Meta and
Paul J. Sachs
1965.253

Vente 1, no. 312 (Fr 5,300);
purchased at that sale by Paul
Rosenberg, Paris; purchased from
him by Paul J. Sachs, Cambridge,
Mass., March 30, 1920 (Fr 7,000);
his bequest to the Fogg Art
Museum, 1965.
[Fig. 5]

39
STUDY FOR "JULIE BURTEY,"
c. 1867
Hard and soft graphite with
touches of white chalk on
off-white wove paper
36.1 x 27.2 cm
Bequest of Meta and
Paul J. Sachs
1965.254

Vente 2, no. 347 (Fr 5,500);
purchased at that sale by Reginald
Davis, Paris; Mme L. Demotte, Paris,
by 1924; purchased from her by Paul
J. Sachs, Cambridge, Mass., July 3,
1928 ($920); his bequest to the Fogg
Art Museum, 1965.
[Fig. 38]

40
STUDY FOR "DIEGO
MARTELLI," 1879
Prepared black chalk
heightened with white chalk,
traces of white gouache, on
green-gray wove paper,
discolored to tan, squared
in black chalk
45 x 28.9 cm
Bequest of Meta and
Paul J. Sachs
1965.255

Vente 3, no. 344a (framed with
1965.256; Fr 935 for the lot of two);
César Mange de Hauke, New York;
purchased from him by Paul J.
Sachs, Cambridge, Mass., by March
1930; his bequest to the Fogg Art
Museum, 1965.
[Fig. 15]

41
STUDY FOR "DIEGO
MARTELLI," 1879
Charcoal heightened with white
chalk on blue-gray wove paper,
discolored to tan, squared in
charcoal
45.3 x 28.8 cm
Bequest of Meta and
Paul J. Sachs
1965.256

Vente 3, no. 344b (framed with
1965.255; Fr 935 for the lot of two);
César Mange de Hauke, New York;
purchased from him by Paul J.
Sachs, Cambridge, Mass., by March
1930; his bequest to the Fogg Art
Museum, 1965.
[Fig. 40]

42
AFTER THE BATH, WOMAN
DRYING HER HAIR, c. 1893–98
Charcoal on pale pink wove
paper
49.7 x 64.4 cm
Bequest of Meta and
Paul J. Sachs
1965.257

Vente 2, no. 289 (Fr 2,200); Sadajiro
Yamanaka, New York; purchased
from him by Paul J. Sachs, Cam-
bridge, Mass., in or before 1932; his
bequest to the Fogg Art Museum,
1965.
[Fig. 33]

Fig. 61, no. 32

Fig. 63, no. 25

Fig. 62, no. 31

Fig. 64, no. 51

Fig. 65, no. 33

Fig. 66, no. 46

Fig. 67, no. 37

Fig. 68, no. 36

Fig. 69, no. 22

Fig. 70, no. 49

Fig. 71, no. 26

Fig. 72, no. 30

Fig. 73, no. 23

43
AFTER THE BATH, WOMAN DRYING HERSELF, c. 1893–98
Charcoal on yellow tracing paper
97.8 x 90.1 cm
Bequest of Meta and
Paul J. Sachs
1965.258

Sadajiro Yamanaka, New York; purchased from him by Paul J. Sachs, Cambridge, Mass.; his bequest to the Fogg Art Museum, 1965.
[Fig. 9]

44
AFTER THE BATH, c. 1892–94
Charcoal and pastel on off-white wove paper
43.5 x 33.2 cm
Bequest of Meta and
Paul J. Sachs
1965.259

Durand-Ruel, New York; purchased from them by Paul J. Sachs, Cambridge, Mass., 1925–29 ($1,500); his bequest to the Fogg Art Museum, 1965.
[Fig. 10]

45
YOUNG WOMAN IN STREET COSTUME, c. 1879
Black ink, gray wash, white and gray gouache with traces of black chalk on tan wove paper, discolored to brown
32.5 x 25 cm
Bequest of Meta and
Paul J. Sachs
1965.260

Durand-Ruel, New York; purchased from them by Paul J. Sachs, Cambridge, Mass., 1925–29 ($1,500); his bequest to the Fogg Art Museum, 1965.
[Fig. 39]

46
ÉDOUARD MANET, c. 1866–68
Prepared black chalk on off-white wove paper, laid down overall to off-white wove paper
36.2 x 23 cm
Bequest of Meta and
Paul J. Sachs
1965.261

Vente 4, no. 248a (framed with another work; Fr 1,600 for the lot of two); Marius de Zayas, New York; purchased from him by Paul J. Sachs, Cambridge, Mass., January 10, 1920 ($350); his bequest to the Fogg Art Museum, 1965.
[Fig. 66]

47
A NUDE FIGURE BATHING, c. 1892–95
Charcoal on white wove paper
65 x 50 cm
Bequest of Meta and
Paul J. Sachs
1965.262

Vente 2, no 342 (Fr 2,400); Marcel Bing, Paris; Sadajiro Yamanaka, New York; purchased from him by Paul J. Sachs, Cambridge, Mass.; his bequest to the Fogg Art Museum, 1965.
[Fig. 74]

48
A BALLET DANCER IN POSITION FACING THREE-QUARTERS FRONT, c. 1872–73
Graphite, prepared black chalk, white chalk, and touches of blue-green pastel on pink wove paper, squared in prepared black chalk
41 x 27.6 cm
Bequest of Meta and
Paul J. Sachs
1965.263

Vente 1, no. 328 (Fr 9,100); César Mange de Hauke, New York; purchased from him by Paul J. Sachs, Cambridge, Mass., April 6, 1929; his bequest to the Fogg Art Museum, 1965.
[Fig. 8]

49
SKETCHES OF DANCERS, c. 1876–77
Brown ink with touches of blue watercolor on off-white modern laid paper
20.1 x 25.1 cm
Bequest of Meta and
Paul J. Sachs
1965.264

Garbis Kalebjian; purchased from him by Paul J. Sachs, Cambridge, Mass., by 1927; his bequest to the Fogg Art Museum, 1965.
[Fig. 70]

50
VIRGIN AND CHILD, AFTER A PAINTING IN THE COLLECTION OF EDMOND BEAUCOUSIN, PARIS, BY A FOLLOWER OF LEONARDO DA VINCI, c. 1857
Graphite on off-white wove paper
33.5 x 25.8 cm
Bequest of Meta and
Paul J. Sachs
1965.265

Vente 4, no. 114b (framed with no. 54 and one other work; Fr 2,320 for the lot of three); Durand-Ruel, New York; purchased from them by Paul J. Sachs, Cambridge, Mass., June 17, 1948; ($1,000); his bequest to the Fogg Art Museum, 1965.
[Fig. 56]

51
GIOVANNA BELLELLI, c. 1858
Red chalk on dark tan wove paper, discolored to brown
31.4 x 22.9 cm
Bequest of Meta and
Paul J. Sachs
1965.266

Edmond de Gas, Paris; by descent to Jeanne Fevre, Nice; Charles E. Slatkin, New York; purchased from him by Paul J. Sachs, Cambridge, Mass., February 23, 1956 ($2,200); his bequest to the Fogg Art Museum, 1965.
[Fig. 64]

52
DANCERS, NUDE STUDY, 1899
Charcoal, red-brown pastel, and white chalk on cream wove paper
78.1 x 58.1 cm
Partial and promised gift of Emily Rauh Pulitzer in honor of James Cuno
2002.303

Ambroise Vollard, Paris; Mr. and Mrs. Paul Obst, Paris and Munich; Walter Feilchenfeldt, Zurich; purchased from him by Louise and Joseph Pulitzer Jr., St. Louis, 1969; by descent to Emily Rauh Pulitzer, St. Louis; her partial and promised gift to the Fogg Art Museum, 2002.
[Fig. 35]

Fig. 74, no. 47

53

VIEW OF MOUNT VESUVIUS,
c. 1856
Graphite on off-white modern
laid paper
26.3 x 38.5 cm
Marian H. Phinney Fund and
through the generosity of the
Dillon Fund, David Leventhal,
Margaret Ellis, Walter and
Virgilia Klein, the Bunge North
America Foundation, and
Morton Abromson and Joan
Nissman in honor of James
Cuno
2003.6

The Drawing Shop, New York; Curtis
O. Baer, New Rochelle, N.Y.; his son,
George Baer, Stone Mountain, Ga.;
Jill Newhouse, New York; purchased
from her by the Fogg Art Museum,
2003.
[Fig. 53]

54

PORTRAIT OF A WOMAN,
AFTER A DRAWING IN THE
UFFIZI THEN ATTRIBUTED
TO LEONARDO DA VINCI,
c. 1858–59
Graphite on off-white wove
paper
35 x 26 cm
Gift of David M. Leventhal '71
in honor of Marjorie B. Cohn
2005.79

Vente 4, 114a (framed with no. 50
and one other work; Fr 2,320 for the
lot of three); Durand-Ruel, New
York; Lillie P. Bliss, New York; her
bequest to the Museum of Modern
Art, New York, 1934; deaccessioned
through Jacques Seligmann & Co.,
Inc., New York, June 1941; Robert L.
Rosenwald, Jenkintown, Penn.;
private collection (?); Sotheby's,
New York, February 21, 1985, no. 154;

purchased at that sale by David M.
Leventhal, New York; his gift to the
Fogg Art Museum, 2005.
[Fig. 14]

55

YOUNG WOMAN LYING ON A
CHAISE LONGUE, c. 1895–1900
Charcoal and pastel on tan
wove paper
33.7 x 54.6 cm
Lent by Mrs. Arthur K.
Solomon, promised gift to
the Fogg Art Museum
TL39532.1

Vente 3, no. 331 (Fr 748); Durand-
Ruel, Paris; Justin K. Thannhauser,
Paris; purchased from him by Arthur
K. Solomon, Cambridge, Mass., by
1937; promised gift to the Fogg Art
Museum.
[Fig. 27]

56

HEAD OF A MAN, 1858
Black and white chalk with
charcoal on off-white wove
paper
38 x 26.4 cm
Promised gift of Emily
Rauh Pulitzer
TL39629

Vente 4, no. 94c; Mlle Romagosa;
her sale, Hôtel Drouot, Paris,
February 7, 1947, no. 42 (Fr 38,100);
purchased at that sale by M.
Dumonteil; purchased from a
private collection, Paris
(Dumonteil's?) by the Galerie
Nathan, Zurich, 1970; purchased
from it by Joseph Pulitzer Jr., St.
Louis; by descent to Emily Rauh
Pulitzer, St. Louis.; her promised
gift to the Fogg Art Museum, 2005.
[Fig. 34]

PRINTS

57

NUDE WOMAN STANDING,
DRYING HERSELF, 1891–92
Lithograph on off-white
imitation laid paper
49.9 x 28.5 cm (sheet)
Delteil 65, Reed and Shapiro
61 iv/vi
Gray Collection of Engravings
and George R. Nutter Funds
G8830

Probably Gustave Pellet, Paris;
probably his son-in-law Maurice
Exsteens, Paris; purchased from
Sagot, LeGarrec et Cie., Paris,
September 15, 1949 ($310.29).
[Fig. 75]

58

MARY CASSATT AT THE
LOUVRE: THE PAINTINGS
GALLERY, 1879–80
Etching and aquatint on heavy
off-white modern laid paper
30.4 x 12.4 cm (plate)
Delteil 29, Reed and Shapiro 52
(from the canceled plate)
Duplicate Sales Fund, by
exchange
M13945

Gropper Gallery, Cambridge, Mass.;
purchased from them, 1962 ($75).
[Fig. 80]

59

NUDE WOMAN STANDING,
DRYING HERSELF, 1891–92
Lithograph on off-white wove
paper
42.5 x 30.5 cm (sheet)
Delteil 65, Reed and Shapiro
61 iv/vi or vi/vi

Bequest of Meta and
Paul J. Sachs
M14294

Probably Gustave Pellet, Paris;
probably his son-in-law Maurice
Exsteens, Paris; Paul J. Sachs,
Cambridge, Mass.; his bequest
to the Fogg Art Museum, 1965.
[Fig. 76]

60

ILLUSTRATION FOR "THE
CARDINAL FAMILY" (PAULINE
AND VIRGINIE CARDINAL
CONVERSING WITH
ADMIRERS), 1876–77
Monotype in black ink on
heavy China paper tipped
onto heavy white wove paper
21.5 x 16.1 cm (plate)
Janis 218
Bequest of Meta and
Paul J. Sachs
M14295

Vente d'Estampes, part of no. 201
(bought in); Degas estate, auction,
Lair-Dubreuil, Paris, 1928; Paul J.
Sachs, Cambridge, Mass.; his
bequest to the Fogg Art Museum,
1965.
[Fig. 82]

61

THE ENGRAVER JOSEPH
TOURNY, 1857
Etching on white wove paper
25 x 14.3 cm (plate)
Delteil 4, Reed and Shapiro 5
Bequest of Meta and Paul J.
Sachs
M14296

Paul J. Sachs, Cambridge, Mass.; his
bequest to the Fogg Art Museum,
1965.
[Fig. 84]

Fig. 75, no. 57

Fig. 77, no. 64

Fig. 76, no. 59

Fig. 78, no. 66

Fig. 79, no. 67

Fig. 80, no. 58

Fig. 81, no. 62

Fig. 82, no. 60

Fig. 83, no. 68

Fig. 84, no. 61

62

SONG OF THE SCISSORS, 1877–78
Monotype on white wove paper
21.6 x 16.1 cm (plate)
Janis 44
Gift of Henry F. Harrison
M15342

Vente d'Estampes, no. 264; purchased at that sale by Gustave Pellet, Paris; Maurice Exsteens, Paris; Paul Brame and César Mange de Hauke, Paris; purchased from them by Charles E. Slatkin Gallery, New York; purchased from them by Henry F. Harrison, Cambridge, Mass.; his gift to the Fogg Art Museum, 1973.
[Fig. 81]

63

THE ROAD IN THE FOREST, c. 1890–93
Monotype in green and brown oil colors on very heavy white wove paper
30 x 40 cm (sheet)
Janis 292
Bequest of Frances L. Hofer
M19786

Maurice Exsteens, Paris; Paul Brame and César Mange de Hauke, Paris; Sir Robert Abdy, London; Sir Valentine Abdy, Paris; purchased from him by Galerie de L'Oeil, Paris; purchased from them by E. V. Thaw and Co., New York; purchased from them by R. M. Light & Co., Boston; purchased from them by Philip Hofer, Cambridge, Mass., 1968 ($7,000); by descent to Frances L. Hofer; her bequest to Harvard University, 1979.
[Fig. 24]

64

LEAVING THE BATH, 1879–80
Drypoint and aquatint on white modern laid paper
12.7 x 12.7 cm (plate)
Delteil 39, Reed and Shapiro 42 v/xxii
Gift of Marjorie B. and Martin Cohn in honor of Emily Rauh Pulitzer
M26274

Alexis Rouart, Paris, probably the gift of the artist to Rouart, in whose house the plate was begun; Galerie Marcel Guiot, Paris, 1933, no. 184 (Fr 5,500); R. M. Light & Co., Boston; purchased from them by Mrs. Hugh Matthews, Boston, 1967; purchased from her by Ruth Boschwitz Benedict, Washington, D.C.; swapped for a Rembrandt etching, *Christ Carried to the Tomb*, by her niece Marjorie Benedict Cohn, Arlington, Mass., 1985; her gift and that of Martin Cohn to the Fogg Art Museum, 2005.
[Fig. 77]

65

LANDSCAPE, 1890–92
Monotype in purple, green, and ochre oil colors on heavy cream wove paper
28.9 x 39.2 (plate)
Janis 309
Partial and promised gift of Emily Rauh Pulitzer in honor of Marjorie B. Cohn
M26275

Maurice Exsteens, Paris; Paul Brame and César Mange de Hauke, Paris; purchased from them by Phyllis Lambert, Chicago, 1958; donated by her to the Canadian Centre for Architecture, Montreal; purchased from it through Martha Beck, New York, by Emily Rauh Pulitzer, St. Louis, 1994; her partial and promised gift to the Fogg Art Museum, 2005.
[Fig. 7]

Long-Term Loans

66

AFTER THE BATH III, c. 1891
Lithograph on cream wove paper
24.6 x 23 cm (sheet)
Reed and Shapiro 65 i/ii
Loan from the Collection of Edouard Sandoz
5.1965

Edouard Sandoz, Paris; by descent.
[Fig. 78]

67

ON STAGE III, 1876–77
Soft-ground etching, drypoint, and roulette on off-white modern laid paper
10 x 12.5 cm (plate)
Delteil 32, Reed and Shapiro 24 ii/v
Anonymous loan in honor of Jakob Rosenberg
29.1979

Vente d'Estampes; August Laube, Zurich; R. M. Light & Co., Boston; purchased from them by current owner, 1969; loan to the Fogg Art Museum, 1979.
[Fig. 79]

68

RENÉ DE GAS, THE ARTIST'S BROTHER, 1861–62
Soft-ground etching on heavy cream wove paper
8.6 x 7.1 cm
Delteil 3, Reed and Shapiro 15
Anonymous loan in memory of Hans Naef
70.2001

Atelier Degas, Paris; Jean Nepveu Degas, Paris; his sale, Drouot Rive Gauche, Paris, May 6, 1976, no. C; purchased at that sale by R. M. Light & Co., Boston; purchased from them by current owner, 1976; loan to the Fogg Art Museum, 2001.
[Fig. 83]

Fig. 85, no. 72

PHOTOGRAPHS

69
UNTITLED (CAPE HORNU, NEAR SAINT-VALÉRY-SUR-SOMME), probably early September 1895
Gelatin silver print, enlarged and printed by Delphine or Guillaume Tasset
27.5 x 37.8 cm
Daniel 34a
Gift of Paul Sachs, transferred from the Fine Arts Library
P1974.4

Found in Degas's studio after his death; Marcel Guérin, Paris; registered by him at the Fogg Art Museum, December 11, 1936, together with nos. 70, 73, and 74; Paul J. Sachs, Cambridge, Mass.; his gift to the Fogg Museum Library, 1942; transferred to the Fogg Art Museum, 1974.
[Fig. 26]

70
UNTITLED (THE HOURDEL ROAD, NEAR SAINT-VALÉRY-SUR-SOMME), probably early September 1895
Gelatin silver print, enlarged and printed by Delphine or Guillaume Tasset
27.8 x 37.8 cm
Daniel 35a
Gift of Paul Sachs, transferred from the Fine Arts Library
P1974.5

Found in Degas's studio after his death; Marcel Guérin, Paris; registered by him at the Fogg Art Museum, December 11, 1936, together with nos. 69, 73, and 74; Paul J. Sachs, Cambridge, Mass.;

his gift to the Fogg Museum Library, 1942; transferred to the Fogg Art Museum, 1974.
[Fig. 44]

71
UNTITLED (SELF-PORTRAIT IN LIBRARY), probably autumn 1895
Gelatin silver print
11.9 x 16.7 cm
Daniel 19b
Richard and Ronay Menschel Fund for the Acquisition of Photographs
P1997.42

Agnes Mongan, Cambridge, Mass.; purchased from her estate by the Fogg Art Museum, 1997.
[Fig. 88]

72
UNTITLED (MADELEINE ESCUDIER LEROLLE AND HENRY LEROLLE), 1895–96
Gelatin silver print, enlarged and printed by Delphine or Guillaume Tasset
28.3 x 38.7 cm
Richard and Ronay Menschel Fund for the Acquisition of Photographs
P2004.60

Madeleine Escudier Lerolle and Henry Lerolle, Paris; by descent to Jacques Lerolle, Paris; his sale, Beaussant & Lefèvre, Drouot Richelieu, Paris, July 2, 2004, no. 215; purchased at that sale by Hans P. Kraus Jr., Inc., New York; purchased from them by the Fogg Art Museum, 2004.
[Fig. 85]

73
UNTITLED (NEGATIVE PRINT OF DEGAS'S PAINTING "WOMAN IRONING," LEMOISNE 686)
Albumen or gelatin silver print, mounted to light green heavy drawing paper
26.7 x 25.4 cm
Daniel 38a

Found in Degas's studio after his death; Marcel Guérin, Paris; registered by him at the Fogg Art Museum, December 11, 1936, together with nos. 69, 70, and 74; present whereabouts unknown. [There is no documentation that the photograph ever left the Fogg Art Museum or that it was given, like nos. 69 and 70, by Paul J. Sachs to the Fogg Museum Library.]
[Fig. 87]

74
UNTITLED (NEGATIVE PRINT OF DEGAS'S PAINTING "WOMAN IRONING," LEMOISNE 361)
Albumen or gelatin silver print, mounted to bright yellow heavy drawing paper
21 x 22.9 cm
Daniel 39a

Found in Degas's studio after his death; Marcel Guérin, Paris; registered by him at the Fogg Art Museum, December 11, 1936, together with nos. 69, 70, and 73; present whereabouts unknown. [There is no documentation that the photograph ever left the Fogg Art Museum or that it was given, like nos. 69 and 70, by Paul J. Sachs to the Fogg Museum Library.]
[Fig. 86]

OTHER ORIGINAL MATERIAL

75
SONNETS
Published in an edition of 20 by A. H. Rouart, Paris, 1914
The Houghton Library
*FC9.D3635.914s

Alexis H. Rouart, Paris; given by him to Paul Poujard, Paris; Les Argonautes, Paris; purchased from it by the Houghton Library with the Amy Lowell Fund, 1995.

76
LETTER TO PAUL ALBERT BARTOLOMÉ
Cauterets, August 18, 1890
The Houghton Library
62M–132

Goodspeed's Book Shop, Boston; purchased from it by the Houghton Library with the Amy Lowell Fund, 1963.

Fig. 86, no. 74

Fig. 87, no. 73

Fig. 88, no. 71